P9-DME-949

THE PORTFOLIOS
OF ANSEL ADAMS

THE PORTFOLIOS
OF ANSEL ADAMS

Introduction by John Szarkowski

A NEW YORK GRAPHIC SOCIETY BOOK

LITTLE, BROWN AND COMPANY · BOSTON

International Standard Book Number: 0-8212-1122-6 (paperback)
International Standard Book Number: 0-8212-0723-7 (hard cover)
Library of Congress Catalog Card Number: 77-71628

Grateful acknowledgment is made to the Sierra Club for permis-
sion to include Portfolio III; to the Varian Foundation and the
Sierra Club for permission to include Portfolio IV; to Parasol
Press, Ltd. for permission to include Portfolios V, VI, and VII;
and to Beaumont Newhall and the Estate of Nancy Newhall for
permission to include the texts for Portfolios V and VI.

First edition, 1977
First printing with laser-scanned separations and new design, 1981
Hard cover: sixth printing, 1986
Paperback: eighth printing, 1986

New York Graphic Society books are published by Little, Brown
and Company (Inc.). Published simultaneously in Canada by Little,
Brown and Company (Canada) Limited.

For the hard cover and paperback editions of *The Portfolios of Ansel
Adams* published in 1981, new laser-scanned, duotone separations
have been made of all photographs, and the type for the seven
portfolios has been reproduced directly from the original portfolio
pages.

Designed by Ann Lampton Curtis
Production coordinated by Nan Jernigan
Type set by DEKR Corporation
Paper is Centura Gloss
Engraved and printed by Gardner/Fulmer Lithograph
Bound by A. Horowitz and Son

PREFACE

I am more than pleased that this new issue of *The Portfolios* was prepared with improved design and printing. The typography from the original portfolios has been faithfully reproduced and the most advanced printing technology, including laser-scanned, duotone separations, has been used. I am also pleased that the book will now appear in paperback as well as hard cover.

My first selection of photographs was "Parmelian Prints of the High Sierras" (*sic*) — eighteen prints on Kodak Vitava Athena Parchment T paper, typography and title imprint by the Grabhorn Press of San Francisco, privately published in 1927. While made with care and devotion, it was more representational in approach than my later productions and reflected a style of work less realized in character and emphasis than my photography after 1930 — the year I saw Paul Strand's negatives in Taos, an experience which profoundly influenced my concept of photography. My friendship and association with Alfred Stieglitz from 1933 to his death in 1946 (and with Beaumont and Nancy Newhall, Edward Weston, friends at The Museum of Modern Art, and others) stimulated me to conceive a personal tribute to Stieglitz's memory. I felt it appropriate to express my thoughts and feelings about him and his remarkable work; the resulting Portfolio I was dedicated to his memory.

My seven portfolios reveal a rather persistent style, through photographs made from 1932 to 1976. I have worked in much the same approach and with the same general techniques for forty-five years. The subjects I have photographed are far more varied than many would expect from most exhibited and published material; the later portfolios especially reveal some fresh facets. However, I have felt no reason for drastic change, and I have always believed it questionable for artists to arbitrarily change their styles — simply to be different or in step with concurrent movements and trends of creative thought. I am aware that I may suddenly change my approach — even my medium! — at any time, but such change must come from a deep conviction rather than an observance of popular fashion. The seven portfolios are, in effect, an excellent cross section of my work since the days of Group f/64. I have intentionally disregarded the chronological sequence of photographs within the portfolios.

I extend deepest appreciation to my colleagues and associates, family and friends, for their support and assistance in all phases of my work. I am thankful to the Grabhorn Press of San Francisco for the typographic design and printing

of the original text inserts for Portfolios I, II, and III; to Lawton Kennedy of San Francisco for the Portfolio IV text; and to Adrian Wilson and George Waters of San Francisco for the texts of Portfolios V, VI, and VII.

I wish particularly to thank Robert Feldman and his associates (Parasol Press, Ltd.) for his warm cooperation in granting reproduction rights for Portfolios V, VI, and VII.

I wish also to thank the United States Department of the Interior and the National Park Service, and the John Simon Guggenheim Memorial Foundation and its former secretary-general, Henry Allen Moe, for assistance in the creation of Portfolio II; Pirkle Jones and Don Worth for their aid in production of Portfolios II and III, respectively; Dorothy Varian, Dr. and Mrs. Edward Ginzton, Mr. and Mrs. Eric Varian, Nancy Newhall, and Liliane De Cock for their assistance with Portfolio IV. With Portfolios V, VI, and VII warm appreciation is due L. M. Rosenthal and Company, New York (V) and to Ted Orland, Phyliss Donohue, James Taylor, Alan Ross, Norman Locks, Andrea Gray, and Bill Turnage. Special thanks are due Bob Feldman for invaluable aid in the production of Portfolio VII. I also express thanks to Mary Alinder for her assistance with the present issue of the book.

It may be of interest that Portfolio I was privately printed in an edition of 75 copies, 10 of which were made especially for E. Weyhe of New York City; Portfolio II was a privately printed edition of 100 numbered copies and 5 presentation copies. Portfolio III was limited to 208 copies, of which 200 were for sale; Portfolio IV was limited to 260 copies, of which 250 were for sale. Portfolios V and VI were each printed in an edition of 110 copies, of which copies for sale were numbered 1 through 100, and 10 copies were lettered A through J; Portfolio VII was limited to 115 copies, of which copies for sale were numbered 1 through 100, and 15 copies were lettered A through O. Each copy of Portfolio VII contained one original Polaroid PolaPan Type 52 Land photograph selected from 57 different images. The mounts of Portfolios I through IV were 14 × 18 inches; those for Portfolios V through VII were 23 × 29 inches.

In retrospect I may wistfully question the inclusion (or omission) of certain images in the original portfolios. The selections were logically and aesthetically agreeable at the time. With these ninety images, comprising in full my seven major portfolios, I must stand.

Carmel, California *Ansel Adams*
January 1981

INTRODUCTION

In the history of modern photography Ansel Adams is something of an anomaly—a triumphant one, but an anomaly nevertheless. In a period when most ambitious photographers have felt fortunate to win the support of one parochial segment of the total audience, Adams has been admired by a constituency so large and diverse that it could, one would have assumed, agree on nothing.

The spectrum of Adams' admirers has extended from the great Alfred Stieglitz, who gave the impression that he abhorred the popular, to successful advertising executives, who are thought to live in terror of the esoteric. Between these poles, Adams' supporters have included an impressive list of critics and historians, younger photographers of high talent, politicians, curators, conservationists, and an army of photographic hobbyists, who are ordinarily interested in no one's work but their own, and who tend to believe that the art of photography is a matter of better lenses or exotic chemical formulae.

The reasons for this almost catholic acclaim are not completely clear, but surely they are based largely on general intuitions that Adams has some privileged understanding of the meanings of the natural landscape, and that through his pictures he has given the rest of us some hint or glimpse of what we also once knew.

Adams would object to being described specifically as a landscape photographer. Like all good artists he distrusts categories, and it is true that he has made many splendid photographs of other sorts of subjects. Nevertheless, it is our prerogative to define the reasons for our own gratitude, and I think we are primarily thankful to Adams because the best of his pictures stir our memory of what it was like to be alone in an untouched world.

It does not advance us very far to note that Adams has made elegant, handsomely composed, technically flawless photographs of magnificent natural landscapes, a subject which, like motherhood, is almost beyond reproach. These attributes are surely virtues. For many they are sufficient virtues, and these many need not wonder what the precise difference is between the best of Adams' pictures and uncounted other neat, clean, and dramatic photographs of the glorious American West.

The difference presumably depends from the fact that Adams understands better the character and significance of his subject matter, and thus is especially

alert to those details, aspects, and moments that are most intensely consonant with the earth's own tonic notes. We must remind ourselves, however, that all we know of Adams' understanding of the earth comes to us not from any direct view into his mind or spirit, but only from photographs, little monochrome substitutes for his ultimately private experience. To the best of our knowledge, he knows no more than he has shown us. As with any artist, his intuitions are finally no better than his prowess.

What Adams' pictures show us is different from what we see in any landscape photographer before him. They are concerned, it seems to me, not with the description of objects—the rocks, trees, and water that are the nominal parts of his pictures—but with the description of the light that they modulate, the light that justifies their relationship to each other. In this context it is instructive to compare Adams' photographs with those of his older friend and neighbor Edward Weston, who photographed much of the same country that Adams has photographed, but who found there a very different species of picture. The landscape in Weston's pictures is seen as sculpture: round, weighty, and fleshily sensuous. In comparison, Adams' pictures seem as dematerialized as the reflections on still water, or the shadows cast on morning mist: disembodied images concerned not with the corpus of things but with their transient aspect.

From the standpoint of craft, Adams' problem is more difficult than Weston's, dealing as it does less with eternal verities than with quicksilver. Those who have wondered whether Adams' legendary technique is in fact altogether necessary, or whether it might be a kind of showy overkill, reveling in an unnecessary perfection, have perhaps not understood the content of Adams' pictures, which describe phenomena as ephemeral and evanescent, in an unpeopled world, as those of his contemporary, Cartier-Bresson, describe in a world of human events. To describe in a small monochrome picture the difference between the twilight of early morning and that of evening, or between the warm sun of May and the hot sun of June, requires that every tone of the gray scale be tuned to a precise relationship of pitch and volume, so that the picture as a whole sounds a chord that is consonant with our memories of what it was like, or our dreams of what it might be like, to stand in such a spot at such a moment.

Adams would perhaps say that it comes down to a question of good description, which is doubtless true but which has caused a good deal of misunderstanding, since the thing being described is not (for example) a mountain but a concept of one way in which a mountain might be transposed into a photograph.

The particular variety of precision which is essential to the success of an Adams photograph is not graphic but tonal. A diagram of the composition of a first-rate Adams would be largely irrelevant. Adams is not much interested in the traditional concept of composition, which is a way of relating the

discrete parts of a picture in terms of mass, torque, inertia, and other similar mechanical notions. He has what is for him a better system. His pictures are unified by the light that describes a coherent space, in which individual objects play only supporting roles.

The skill with which Adams translates the anarchy of the natural world into these perfectly tuned chords of gray creates a sense of heightened order that is often mistaken by nonphotographers for sharpness. In fact Adams' photographs are no sharper—no more optically acute—than those of any other competent technician using similar tools. They are more *clear*—a matter not of better lenses but of a better understanding of what one means.

<center>✠</center>

If it is true that Adams' work is based on the translation of light into precise tonal relationships, then it is clear that for him the original print—which allows the most exact control over these relationships—is not an exercise in exquisite refinement, but the ultimate reality and central discipline of his art. Adams' best prints are no better than his best seeing requires.

For the same reason—necessity—Adams has for forty years demanded, promoted, and generally received much better photomechanical reproduction for his many books than most photographers would have considered necessary, and often better than the printers themselves knew they were capable of. The standard of photomechanical reproduction that is satisfactory for most luxury picture books is not satisfactory for Adams' work, for such reproduction edits out the subtle shadings of tonality that can describe the character of natural light at a specific place and moment. On the other hand, the very best printing can—not in every case, but sometimes—stand virtually as a surrogate for a perfect photographic print.

At this late date we must remind ourselves that photogaphy, during most of its first century, was known primarily through the medium of original photographic prints. Until World War I photographs were manufactured in significant quantities, as bread and shoes were, even in modest towns, in order to publish the community's scenic wonders, industrial achievements, and notable citizens. Only in the past fifty years have professional photographers come to assume that they were to make their livings by selling reproduction rights rather than actual photographs.

The new system was easier, often more profitable, and in some respects more satisfying. The photographer now needed to make only one print from his negative, for delivery to the photoengraver, who would begin the process of multiplying it for an audience of thousands or millions, through its publication in periodicals. This procedure had only two disadvantages. The photographer—now a member of a committee rather than an independent publisher—surrendered much of his control over the content and the quality of his work.

Under the new dispensation an ambitious photographer who continued to try to sell original prints did so for one of two reasons: either he wished to make pictures for which there was no recognized mass market, or he wished to make pictures which required a precision of statement that the photoengraver could not normally reproduce. For Adams, both conditions obtained. He wanted to make perfect photographs of a landscape he knew and loved, including mountains that were not as tall or as newsworthy as Mount Everest, waterfalls that were insignificant in comparison with Victoria or Niagara, and glacial lakes so small that one could put a thousand of them in Lake Erie without much improving it. To make matters worse Adams was making such pictures during a great world depression (and a quarter century before ecology became an undergraduate password), during which period it was clearly understood that the important issues involving nature had to do with dust storms, floods, drought, grasshoppers, and hurricanes, and not with the jewel-like perfection of a frigid pond in the High Sierra.

This is to say that the market for the pictures that Adams most wanted to make was limited, so limited in fact that it could be satisfied by the slow, demanding, old-fashioned method of making original prints.* And since the public for such work was small at best, one need not worry much about what might most surely please it. Thus, of all Adams' publications, his portfolios most clearly represent his personal view of the meaning of his work.

Small is of course a relative term. It is probable that Ansel Adams has produced in his own darkrooms more carefully considered and fastidiously finished prints than any photographer of the twentieth century. The plates in this book, reproducing the pictures in Adams' seven numbered portfolios, represent a total of some thirteen thousand individual prints, made between the years 1948 and 1976. This is a very impressive number for a modern photographer, but it cannot compare with the output of artists who have worked energetically in the traditional graphic media. The total number of original prints by Picasso—probably the champion producer since Daumier—has been estimated at one hundred and ninety thousand.

It is, unhappily, more difficult and more time-consuming to make a perfect print from a photographic negative than from an etching plate or a lithographic stone. The traditional graphic techniques transmit a simple yes-or-no signal, while the photographer's negative is highly plastic, allowing a broad range of variation that demands not only good craft but critical interpretation. In rough metaphor, the photographer's negative is to the etcher's plate as the violin is to the drum. Furthermore, once the etcher's print looks right, the etcher's work is done. When the photographer's print looks right

* The point was made succinctly by the fictitious fashion photographer Richard Avery, played by Fred Astaire in the movie *Funny Face* (1956), who said, "You would be amazed at how small the demand is for pictures of trees."

it is possessed by a half-dozen chemical devils that will destroy its perfection if not exorcised by hours of tedious donkeywork.

The traditional chemical methods of making photographs, in which the image is formed by molecular metal reduced from metallic salts, is and always has been an unsatisfactory method of making large numbers of multiple prints. It remains, however, a method by which the photographer can achieve a more complete, elegant, subtle, and satisfactory translation of the image formed by his camera's lens than is available from any other system. Further, while it is an impossibly tedious and expensive way of making one thousand duplicate prints, it is the best and cheapest way to make one. Photographers assume therefore that, until the techniques available to them are radically revised, their most serious, personal, and speculative work will continue to be done by the ancient and troublesome chemical methods.

On the other hand, work that has won a substantial audience (or won the support of an angel who is persuaded that it should have a substantial audience) can now be photomechanically reproduced so well that the reproduction can stand almost as a fully vested representative of the original print. Not quite, but almost.

<center>⊞</center>

Serious photographers believe that photography is something larger and more inclusive than the sum of all photographs made thus far, larger even than all those that will be made in the future, and that the chief adventure of the medium lies not in using what is known but in learning more. It seems clear that the best, most interesting photographers have indentured themselves to this ideal, and that this generic artistic ambition has taken precedence over the claims of the specific subject matter with which they have chosen to work. To some degree, the mountain, or the historic human event, has been a pretext for picture-making.

Nevertheless, artists, unlike philosophers, must deal with physical specifics. The photographer especially, being least able of all artists to achieve synthesis, must depend on its opposite: symbol. Large issues must be inferred from trivial data. One family picnic on the banks of the Marne, clearly seen, may stand for civilization; one unfolding fern, for freedom.

If this suggests the game that photographers play, it should be added that the game can be played well only in an environment in which the photographer is knowledgeable and at home, and in which the subtle distinctions of meaning inherent in subject matter are understood and appreciated.

In the specific case of Ansel Adams one might guess that he is even more committed to the ideal of making one perfect photograph than he is to the goal of expressing the beauty and meaning of the wild landscape. But if he does not love and wish to understand the wild landscape, where will he find the energy and tenacity needed to see his subject, coldly and clearly, as a picture?

Ansel Adams was born in 1902, in San Francisco. He began to photograph the landscape of the American West more than fifty years ago, before the Model A had begun to replace the Model T. At that time there were no superhighways, no motels, and no passenger airlines. San Francisco and New York were, by crack train, four splendid days apart.

In those days the world was still a reasonably commodious place, and it was natural to assume that its various parts would retain their discrete, articulated character if they could be protected from the depredations of the lumber, mineral, and water barons. Conservation then was a matter of seeking the support of the people against the encroachment of the powerful few. If one could describe in photographs how much like Eden was Yosemite Valley the electorate would presumably save it from its its exploiters. It was not foreseen that the people, having saved it, would consider it their own, nor that a million pink-cheeked Boy Scouts, greening teenage backpackers, and middle-aged sightseers might, with the best of intentions, destroy a wilderness as surely as the most rapacious of lumbermen, who did his damage quickly and left the land to recover if it could.

It has developed, in other words, that to photograph beautifully a choice vestigial remnant of natural landscape is not necessarily to do a great favor to its future. This problem is now understood, intuitively or otherwise, by many younger photographers of talent, who tend to make landscapes of motifs that have already been fully exploited and that have therefore nowhere to go but up. It is difficult today for an ambitious young photographer to photograph a pristine snowcapped mountain without including the parking lot in the foreground as a self-protecting note of irony.

In these terms Adams' pictures are perhaps anachronisms. They are perhaps the last confident and deeply felt pictures of their tradition. It is possible that Adams himself has come to sense this. The best of his later pictures have about them a nervous intensity that is almost shrill, a Bernini-like anxiety, the brilliance of a violin string stretched tight.

It does not seem likely that a photographer of the future will be able to bring to the heroic wild landscape the passion, trust, and belief that Adams has brought to it. If this is the case, his pictures are all the more precious, for they then stand as the last records, for the young and the future, of what they missed. For the aging—for a little while—they will be a souvenir of what was lost.

John Szarkowski

PORTFOLIO ONE

Twelve Photographic Prints

by

ANSEL ADAMS

SAN FRANCISCO

1948

To photograph truthfully and effectively is to see beneath the surfaces and record the qualities of nature and humanity which live or are latent in all things. Impression is not enough. Design, style, technique,—these, too, are not enough. Art must reach further than impression or self-revelation. Art, said Alfred Stieglitz, is the affirmation of life. And life, or its eternal evidence, is everywhere.

Some photographers take reality as the sculptors take wood and stone and upon it impose the dominations of their own thought and spirit. Others come before reality more tenderly and a photograph to them is an instrument of love and revelation. A true photograph need not be explained, nor can be contained in words.

Expressions without doctrine, my photographs are presented here as ends in themselves, images of the endless moments of the world. I dedicate them to the memory and to the spirit of Alfred Stieglitz.

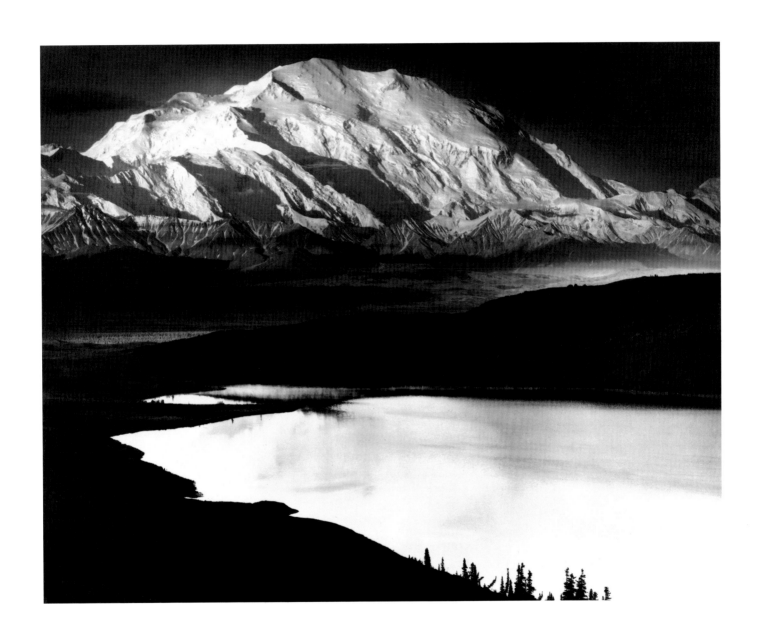

I / Plate 1

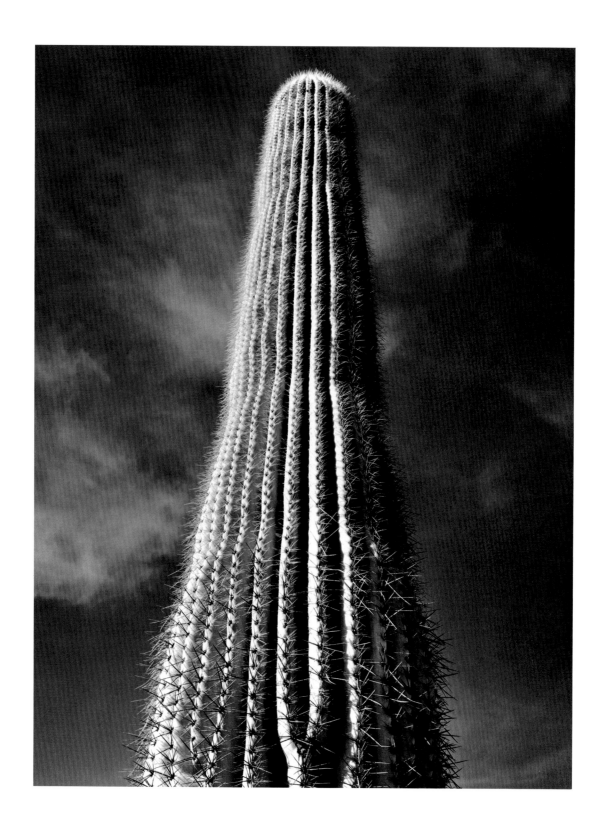

I / Plate 2

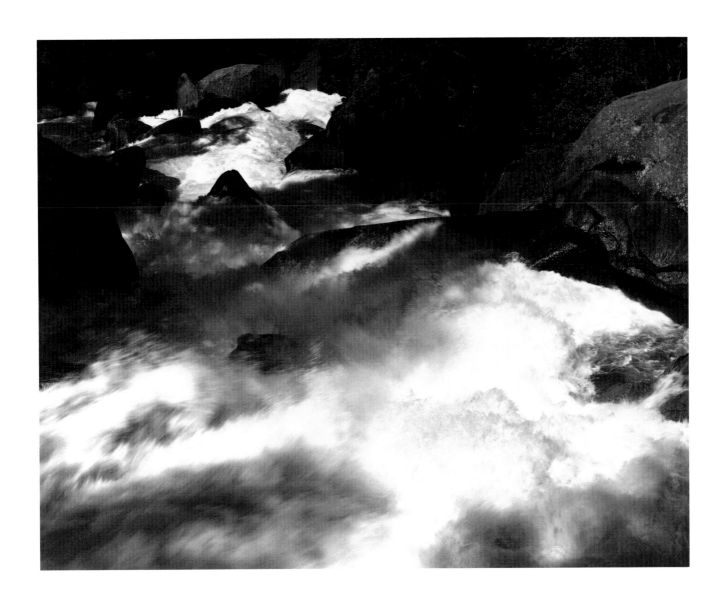

I / Plate 3

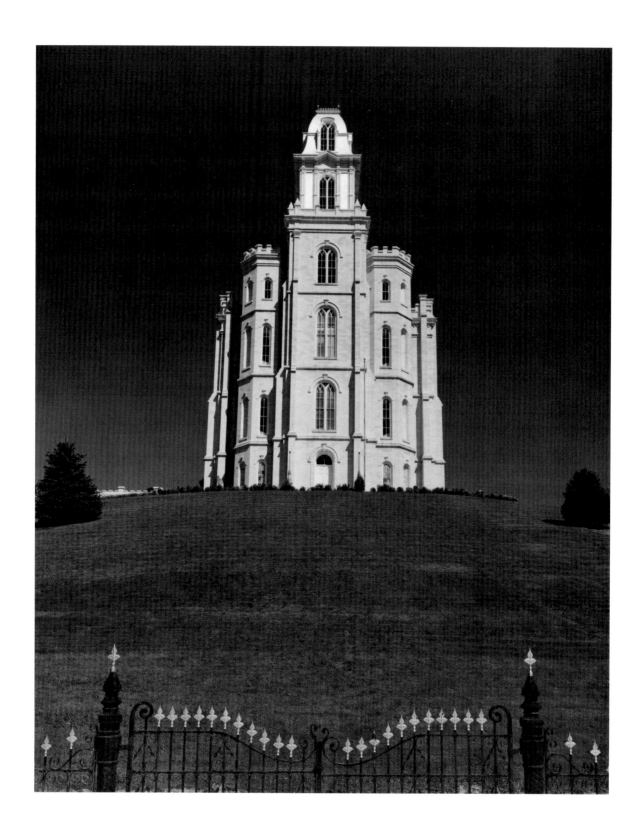

I / Plate 4

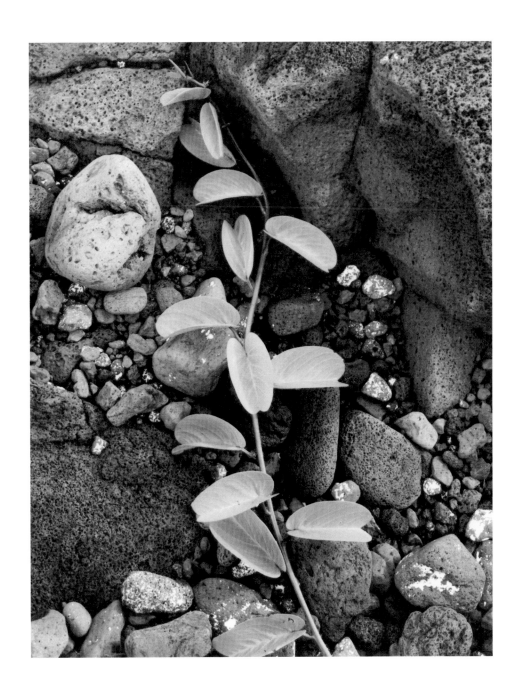

I / Plate 5

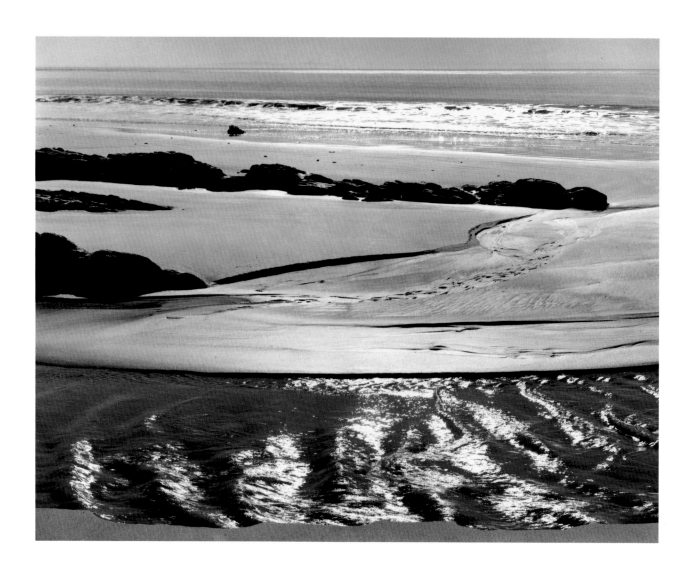

I / Plate 6

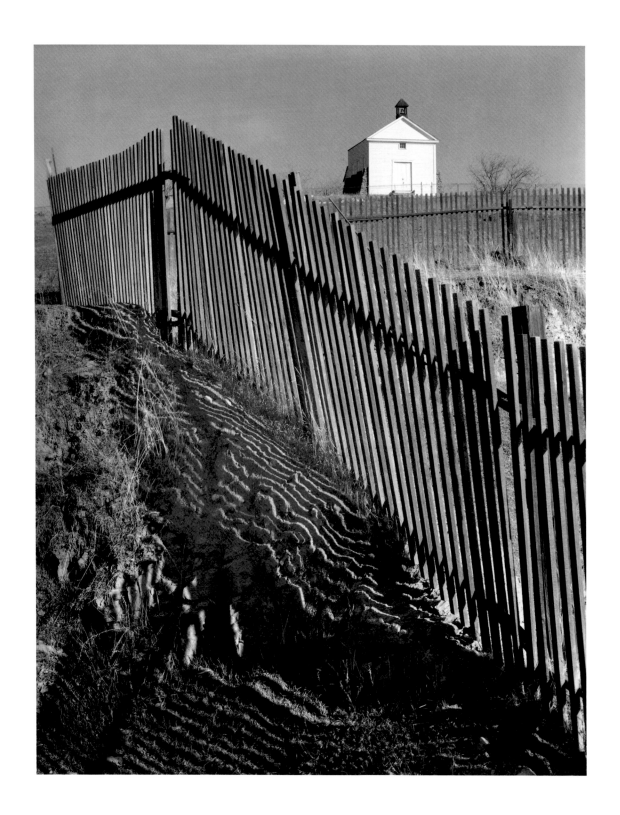

I / Plate 7

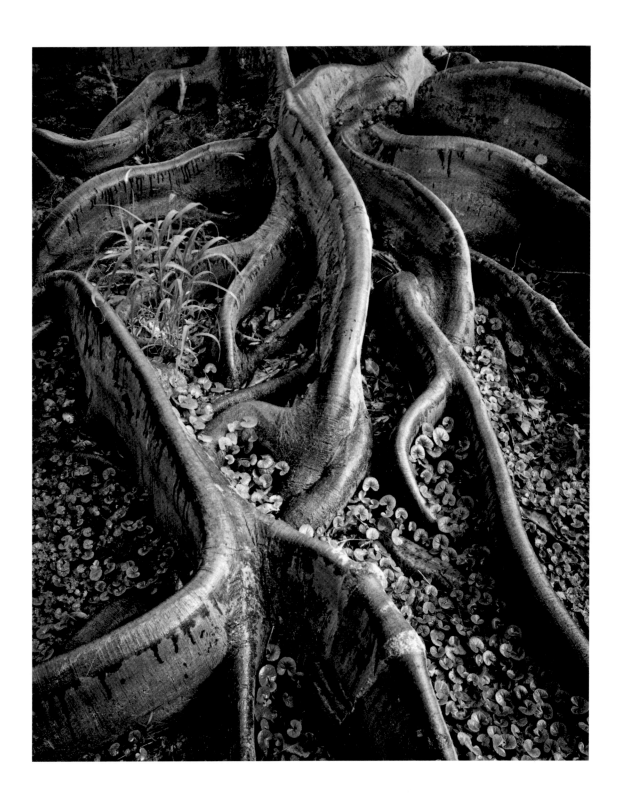

I / Plate 8

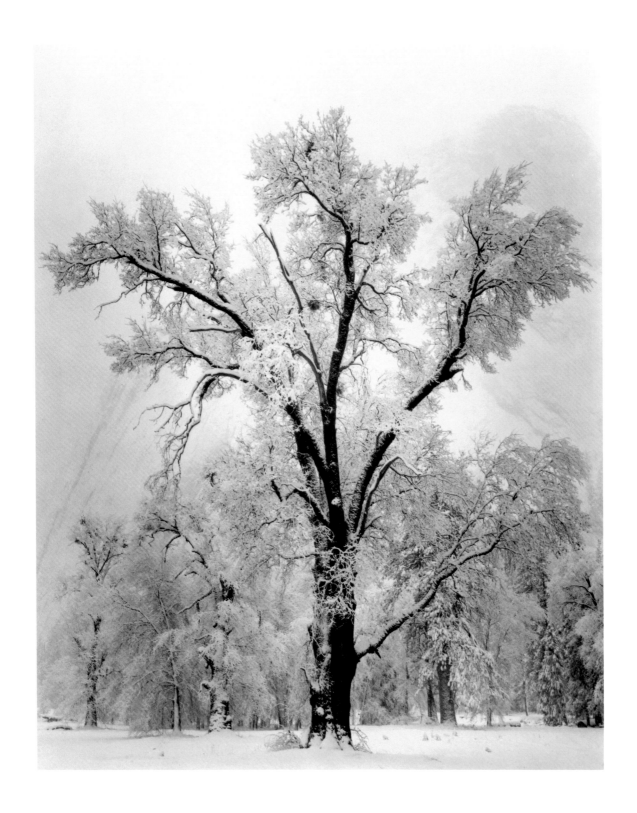

I / Plate 9

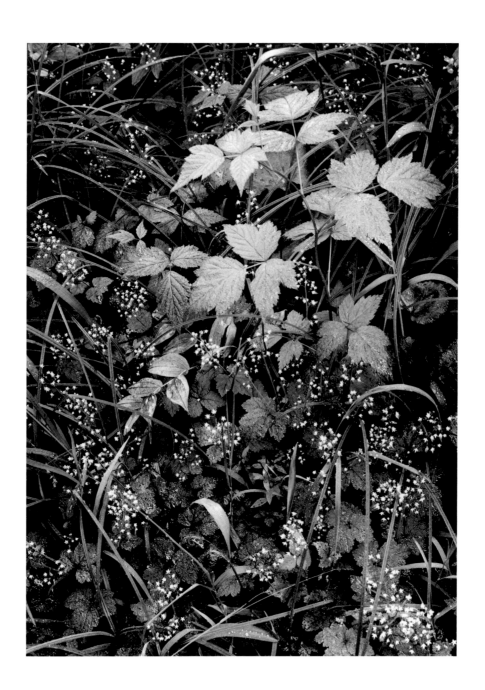

I / Plate 10

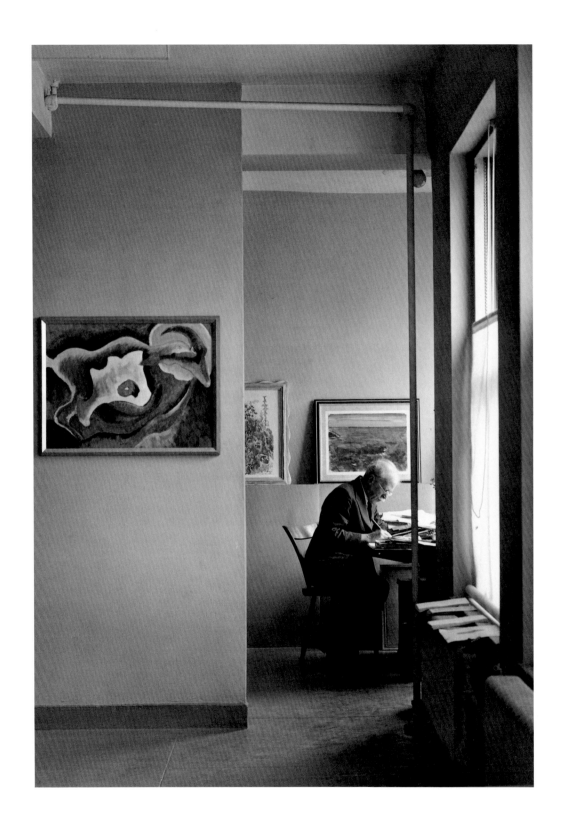

I / Plate 11

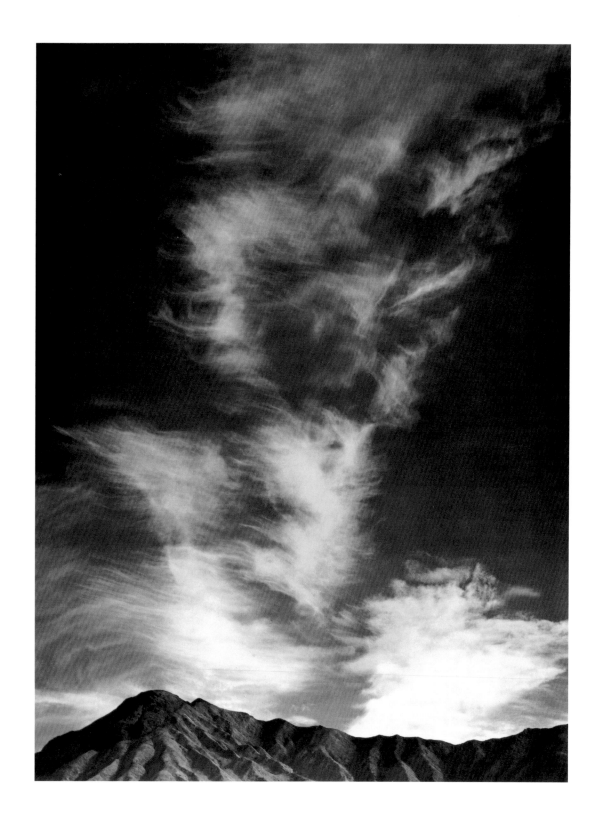

I / Plate 12

PORTFOLIO TWO

THE NATIONAL PARKS &
MONUMENTS

15

PHOTOGRAPHS BY
ANSEL ADAMS

SAN FRANCISCO

1950

ABOUT TWENTY-FIVE YEARS AGO, AT THE HOME OF MY DEAR FRIEND CEDRIC WRIGHT IN BERKELEY, I FIRST MET A LITTLE MAN WITH A MIGHTY HEART. HE SAW SOME OF MY EARLIEST MOUNTAIN PHOTOGRAPHY AND PROMPTLY, WITH CONVICTION, HE ENCOURAGED ME TO FOLLOW THE CAMERA. THROUGHOUT THE YEARS HE WAS AN UNFAILING FRIEND AND PATRON, A SOURCE OF WISDOM AND SPIRIT. INFORMED WITH A LUMINOUS BELIEF IN THE IMPORTANCE OF BEAUTY AND IN THE INTEGRITY OF THE INDIVIDUAL, HE BROUGHT TO ME – AND TO COUNTLESS OTHERS – AID AND CONFIDENCE AND A CLEAR SENSE OF THE OBLIGATIONS OF THE CREATIVE SPIRIT. IN GRATITUDE FOR THE FAITH HE PLACED IN ME SO LONG AGO,

I DEDICATE THIS WORK TO THE MEMORY OF

ALBERT BENDER

To the United States Department of the Interior and the National Park Service, and to the John Simon Guggenheim Memorial Foundation and its Secretary-General, Henry Allen Moe, I express my deep appreciation for the understanding and invaluable assistance which made possible the creation of these photographs. And to Pirkle Jones, good friend and fine photographer, my warmest thanks for his aid in the production of this portfolio.

The edition is limited to 100 numbered copies
and five presentation copies.
COPY NUMBER

Typography by The Grabhorn Press

List of the Prints

NOTES

The contact prints (Nos. 1, 2, 3, 4, 7, 8, 9, 11, 12), and the enlargements (Nos. 5, 6, 10, 13, 14, 15), were made on bromo-chloride projection papers, developed in Metol-Glycin, occasionally supported by addition of Hydroquinone, and toned in selenium. The prints are dry-mounted on Strathmore Drawing Board. In the unlikely event of their becoming detached from the mounts, DO NOT attempt to use paste or glue. Have an experienced professional remount them by the original dry-mounting process.

The surface of these photographs is delicate. To protect them from scratches and abrasions, the paper interleaves should always be replaced whenever the portfolio is handled. When displayed on the wall, the prints should always be under glass.

———

This portfolio is conceived as an expressive whole. It is one of a limited edition, and the fifteen prints are not available separately. Ansel Adams reserves all reproduction rights to the fifteen photographs in Portfolio Two.

This then is life,

Here is what has come to the surface after so many throes and convulsions

How curious! How real!

Underfoot the divine soil, overhead the sun.

Each is not for its own sake,

I say the whole earth and all the stars in the sky are for religion's sake.

I say no man has ever yet been half devout enough,

None has ever yet adored or worship'd half enough,

None has begun to think how divine he himself is, and how certain the future is.

Was somebody asking to see the soul?

See, your own shape and countenance, persons, substances, beasts, the trees,

 the running rivers, the rocks and sands.

All hold spiritual joys and afterwards loosen them;

How can the real body ever die and be buried?

A world primal again, vistas of glory incessant and branching . . .

You oceans that have been calm within me! How I feel you, fathomless, stirring,

 preparing unprecedented waves and storms . . .

Hear the loud echoes of my songs . . .

WALT WHITMAN
Starting from Paumanok

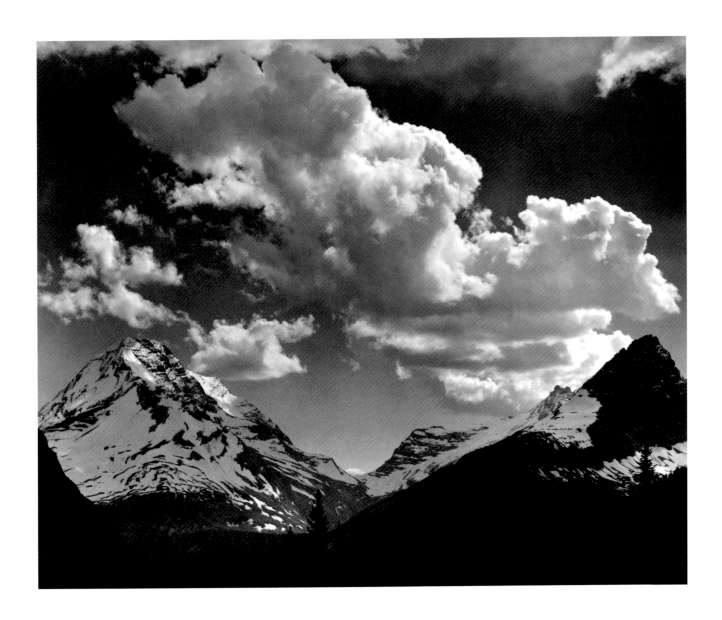

II / Plate 1

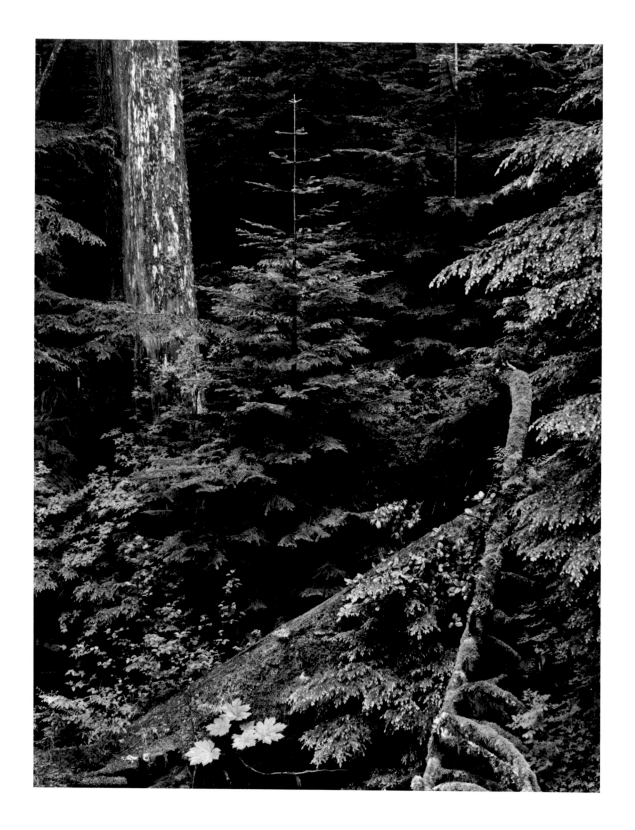

II / Plate 2

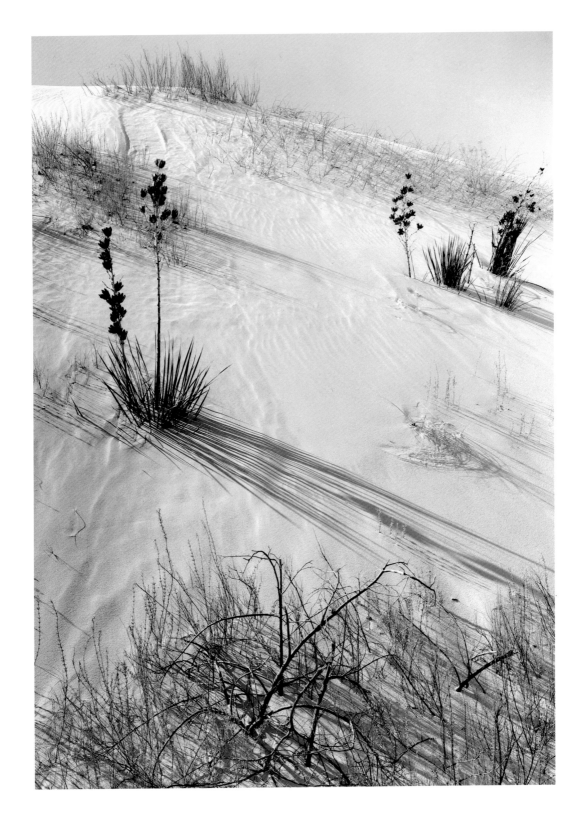

II / Plate 3

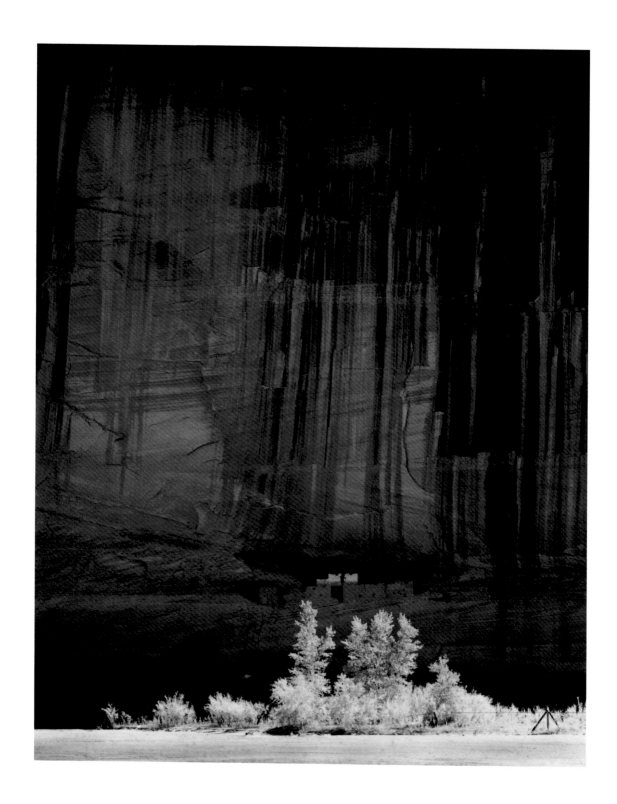

II / Plate 4

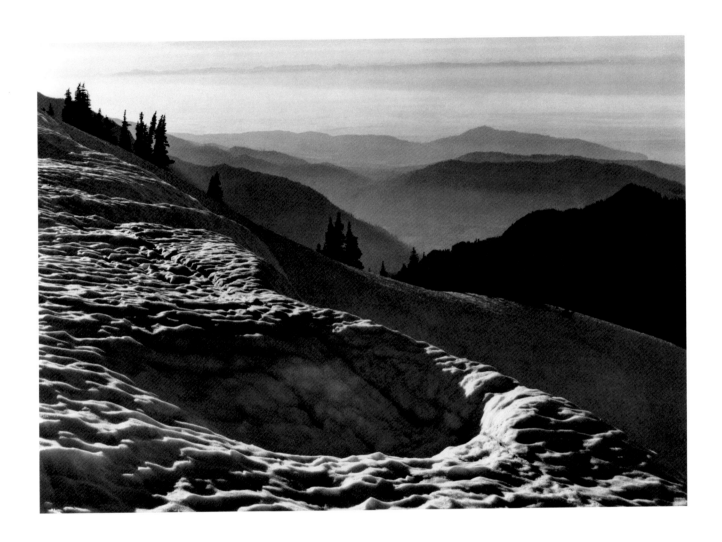

II / Plate 5

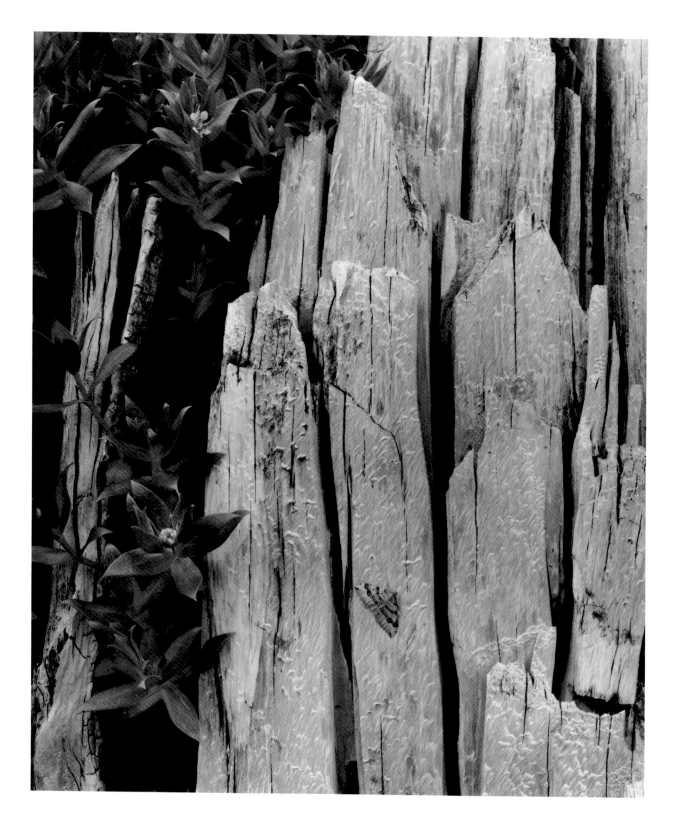

II / Plate 6

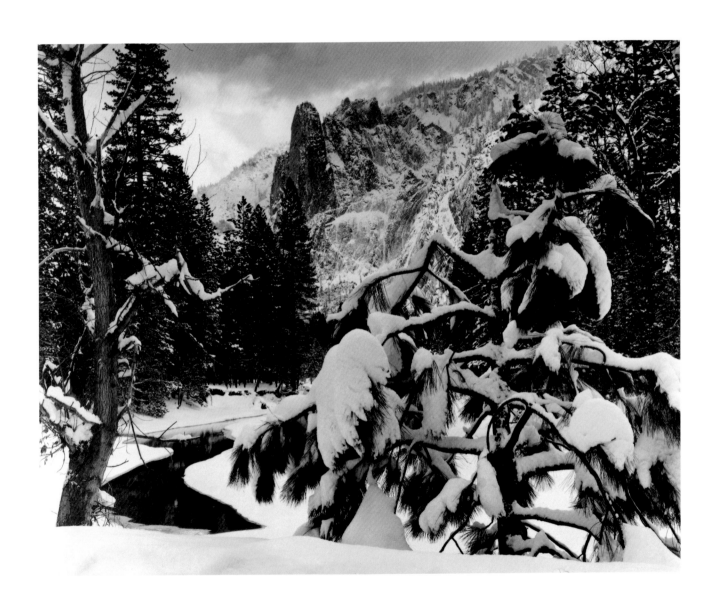

II / Plate 7

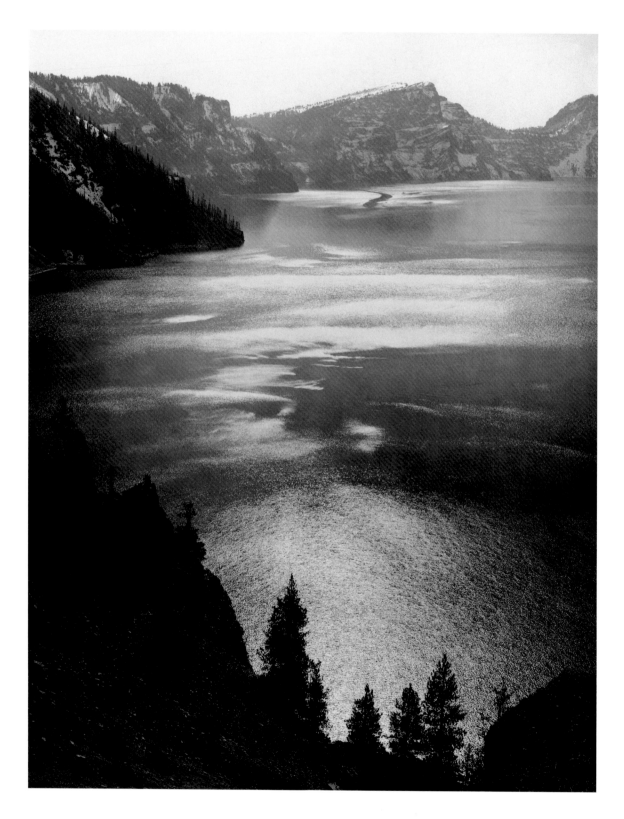

II / Plate 8

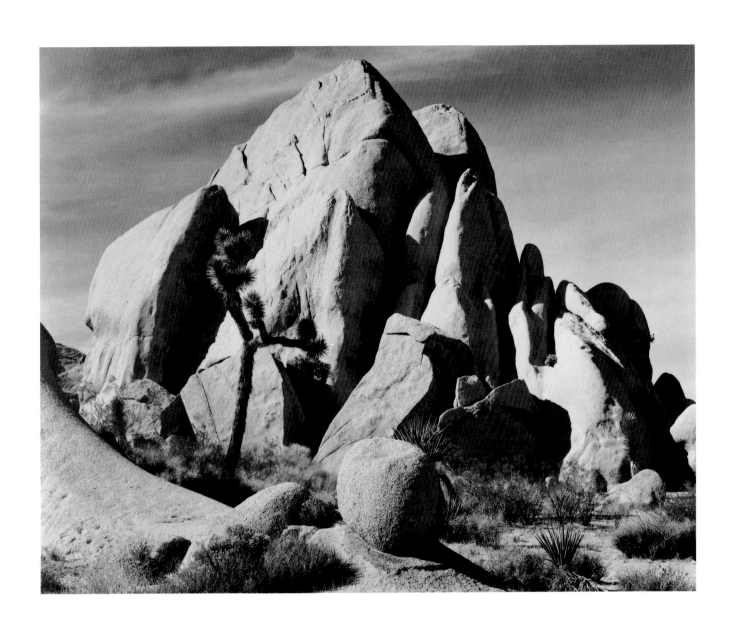

II / Plate 9

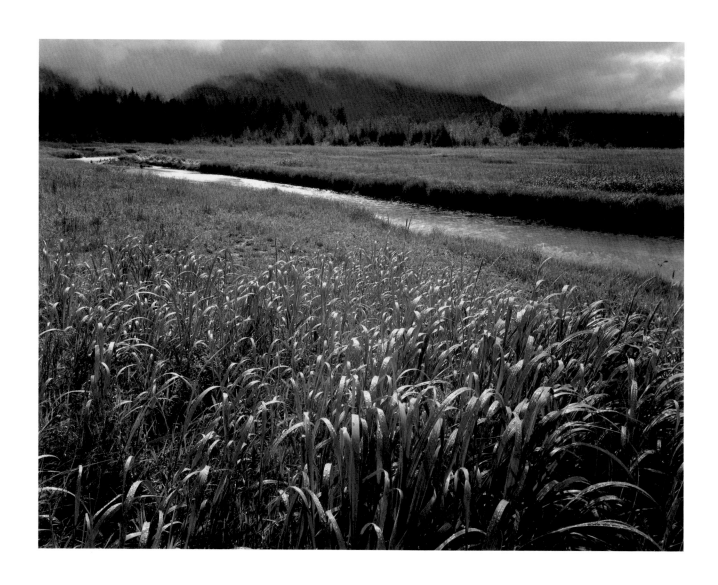

II / Plate 10

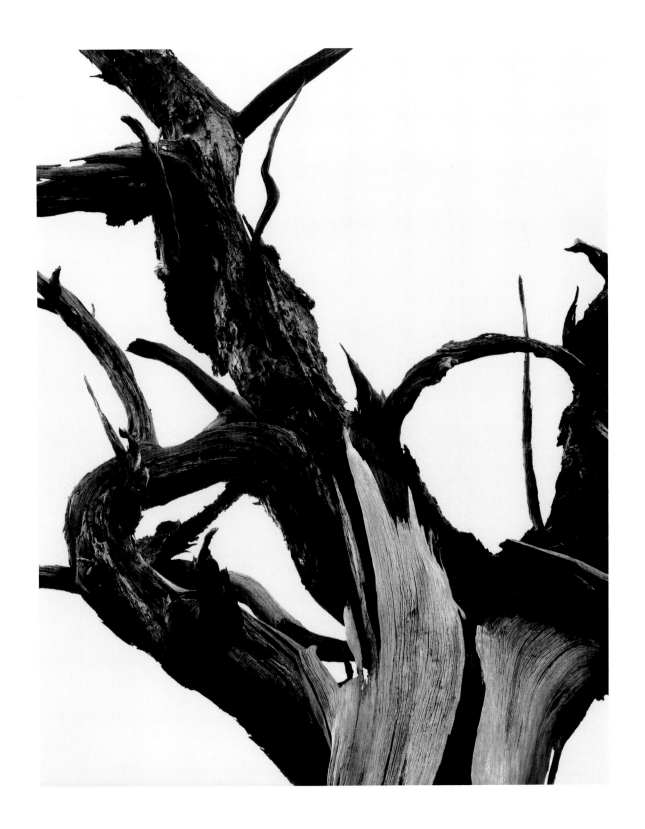

II / Plate 11

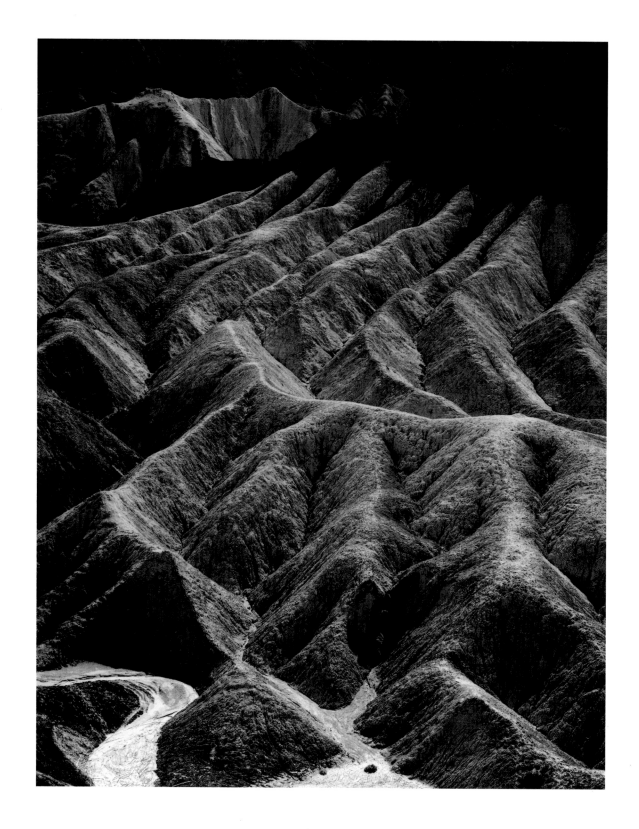

II / Plate 12

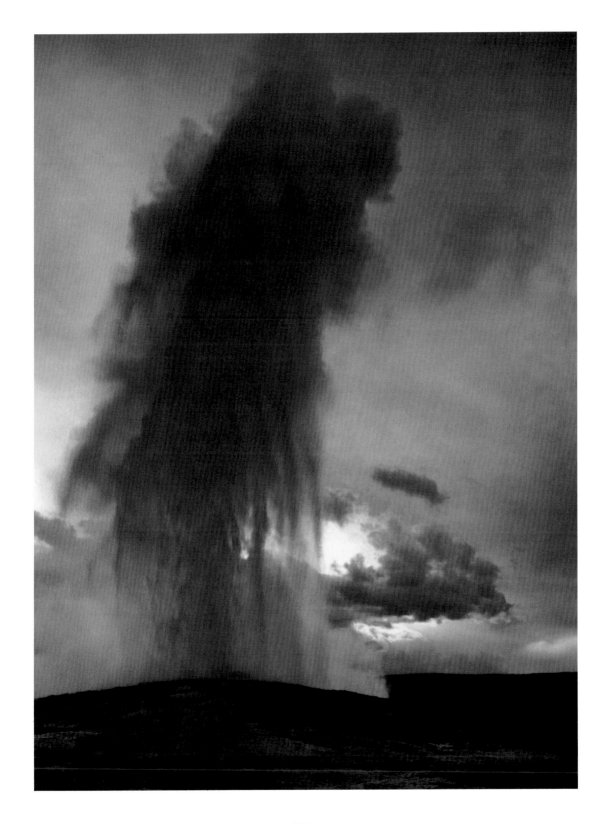

II / Plate 13

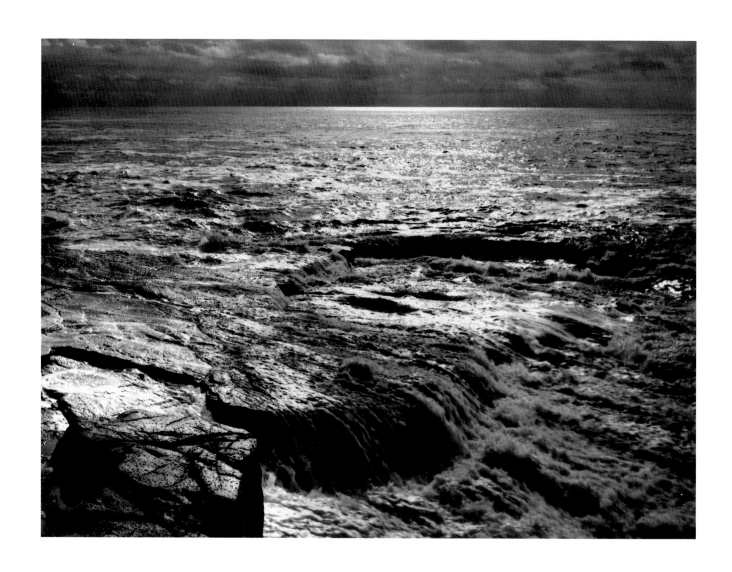

II / Plate 14

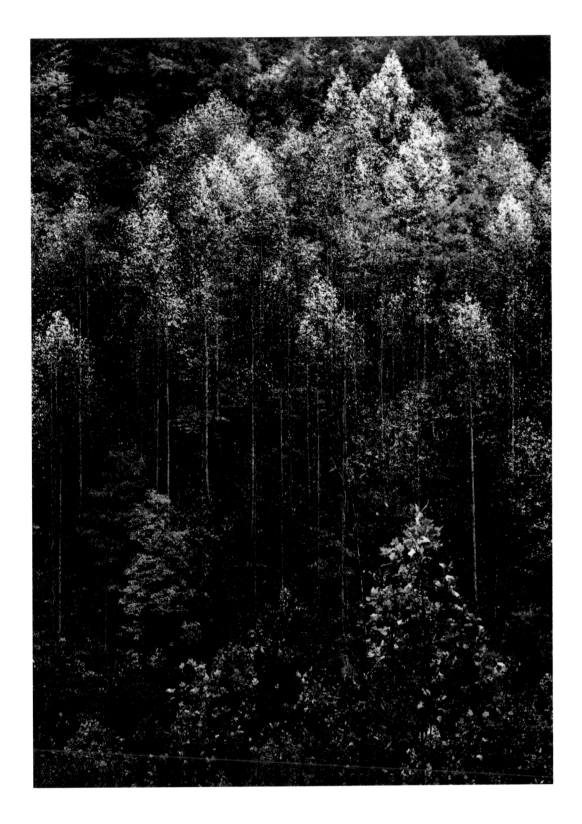

II / Plate 15

PORTFOLIO THREE

YOSEMITE VALLEY

Sixteen Original Photographic Prints by

ANSEL ADAMS

SIERRA CLUB :: SAN FRANCISCO

1960

List of Prints

—◦—◄◄✕◈✕►►—◦—

DEDICATED TO

NANCY AND BEAUMONT NEWHALL

YOSEMITE VALLEY, to me, is always a sunrise, a glitter of green and golden wonder in a vast edifice of stone and space. I know of no sculpture, painting, or music that exceeds the compelling spiritual command of the soaring shape of granite cliff and dome, of patina of light on rock and forest, and of the thunder and whispering of the falling, flowing waters. At first the colossal aspect may dominate; then we perceive and respond to the delicate and persuasive complex of nature.

After the initial excitement we begin to sense the need to share the living realities of this miraculous place. We may resent the intrusion of urban superficialities. We may be filled with regret that so much has happened to despoil, but we can also respond to the challenge to re-create, to protect, to re-interpret the enduring essence of Yosemite, to re-establish it as a sanctuary from the turmoil of the time.

How may we accomplish this?

Who can define the moods of the wild places, the meaning of nature in domains beyond those of material use? Here are worlds of experience beyond the world of the aggressive man, beyond history, and beyond science. The moods and qualities of nature and the revelations of great art are equally difficult to define; we can grasp them only in the depths of our perceptive spirit.

Perhaps age must remember the clear perceptions of youth and return to the sensing of freshness, of strength, and of wonder; perhaps age needs to recall the beginnings of comprehension of mood and meaning and to rekindle an appreciation of the marvelous, of being in resonance with the world. If a man nurtures his sensitive awareness of the natural world with experience and contemplation, his spirit will remain young.

In these sixteen photographs are many deep echoes of experience from more than forty years in Yosemite Valley. Each represents, for me, a moment of wonder. The pictures are put together as a continual pattern of personal mood and response; they do not attempt a complete pictorial exposition of Yosemite, nor are they organized chronologically. A certain sequence is indicated for esthetic reasons,

yet each photograph should stand on its own merit and appeal. This collection is, in a way, a personal autobiography in photographic images, the selection of which is based on emotional impulse and personal experience rather than on intellectual or historical judgment.

Both the grand and the intimate aspects of nature can be revealed in the expressive photograph. Both can stir enduring affirmations and discoveries, and can surely help the spectator in his search for identification with the vast world of natural beauty and wonder surrounding him—and help him comprehend man's continuing need for that world.

—ANSEL ADAMS

N O T E S

The photographs herein cover a considerable span of time – from 1926 (Monolith, the Face of Half Dome, Print 1) to 1959 (Tenaya Creek, Spring Rain, Print 7), but they are not arranged in chronological order. For those interested in photographic technique the following notes will be of interest.

The negative materials used vary from Wratten Glass Plates (Print 1) to Ansco Super Hypan, and the cameras employed from standard view cameras (8 x 10, 6½ x 8½, 5 x 7 and 4 x 5) to the Hasselblad (2¼ x 2¼) single-lens reflex. Negative development for the large images was Pyro, Kodak D-23 and DK-50, and Ansco 47, and for the Hasselblad images (Prints 8 and 13) Kodak DK-20 and Edwal Minicol. Filters were used sparingly, except for Print 1, where a deep red filter (Wratten 29) produced the intentionally dramatic effect.

All prints were made on Kodak Medalist F double-weight paper (glossy, but not ferrotyped) by contact printing (Prints 1, 2, 3, 6, 7, 9, 12, 15, and 16) or by projection printing (Prints 4, 5, 8, 10, 11, 13, and 14), and developed in Edwal Super-111 developer with occasional addition of appropriate amounts of Edwal Orthozite. The prints were fixed for 4 to 5 minutes in Kodak F-5 fixing bath, then rinsed and stored in water. A second fixing (in plain hypo solution) for several minutes was followed by immediate immersion (without rinsing) for 5 to 10 minutes in Kodak hypo-eliminator solution, to which was added 100 to 200 cc Kodak Selenium Toner. The prints were then washed and dried face down on plastic screens without application of heat. All prints were dry-mounted on Strathmore Illustration Board.

PLEASE NOTE : As the prints are mounted by the dry-mounting process they should remain firmly attached to the mounts indefinitely. However, should any print become detached – in whole or in part – from the mount, do not attempt to remount with ordinary adhesives; take the print to a reputable photo-technician for remounting in a dry-mounting press.

The edition is limited to 208 copies of which 200 are for sale.

This is Copy Number

TYPOGRAPHY BY THE GRABHORN PRESS, SAN FRANCISCO

CASES BY PERRY DAVIS, BELMONT, CALIFORNIA

I wish to express my thanks to Don Worth who provided invaluable assistance in the preparation of this portfolio, and to all my friends who gave wise counsel and encouragement.

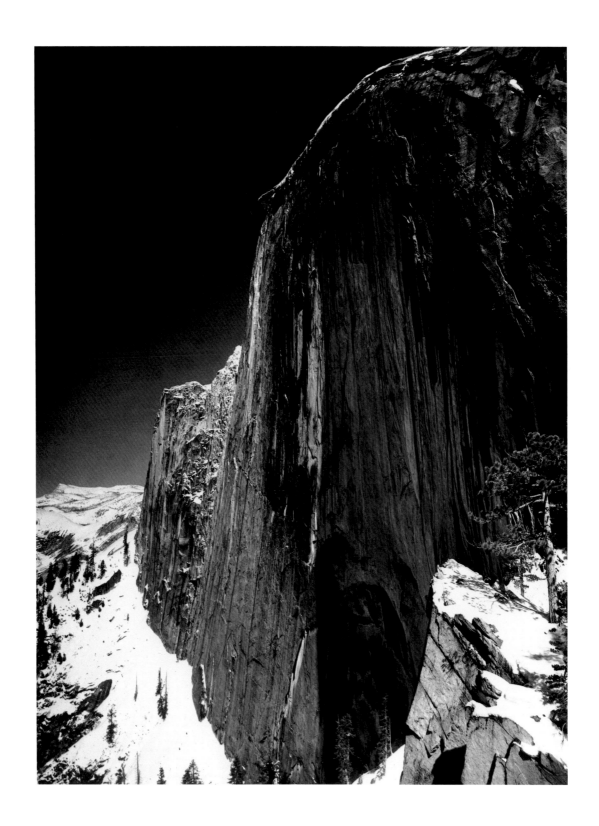

III / Plate 1

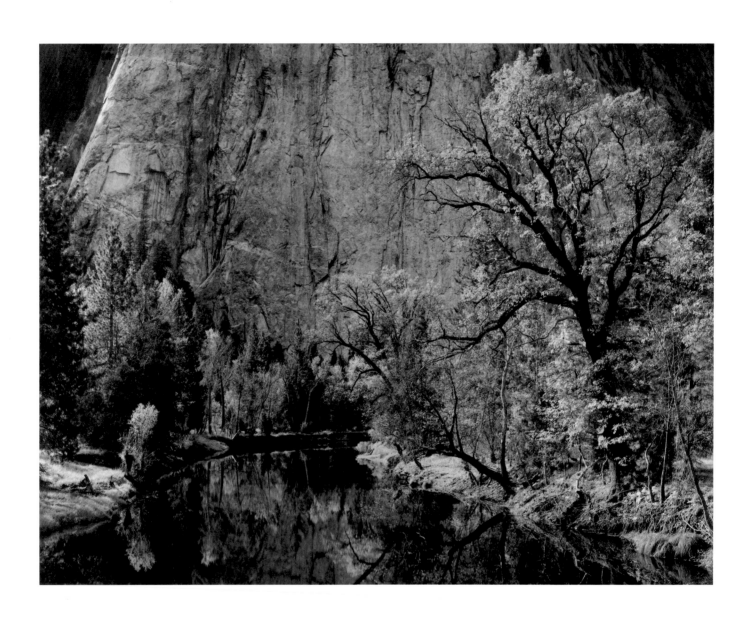

III / Plate 2

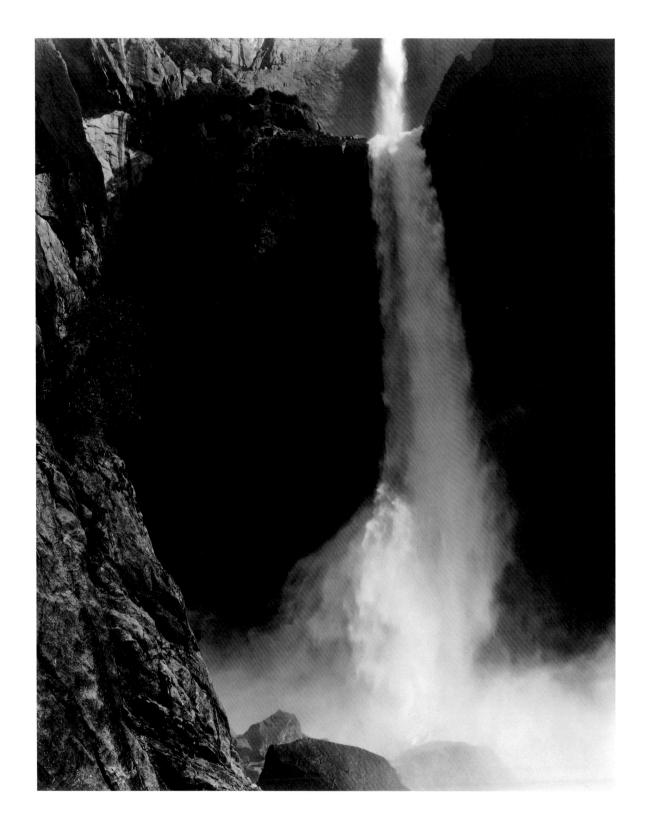

III / Plate 3

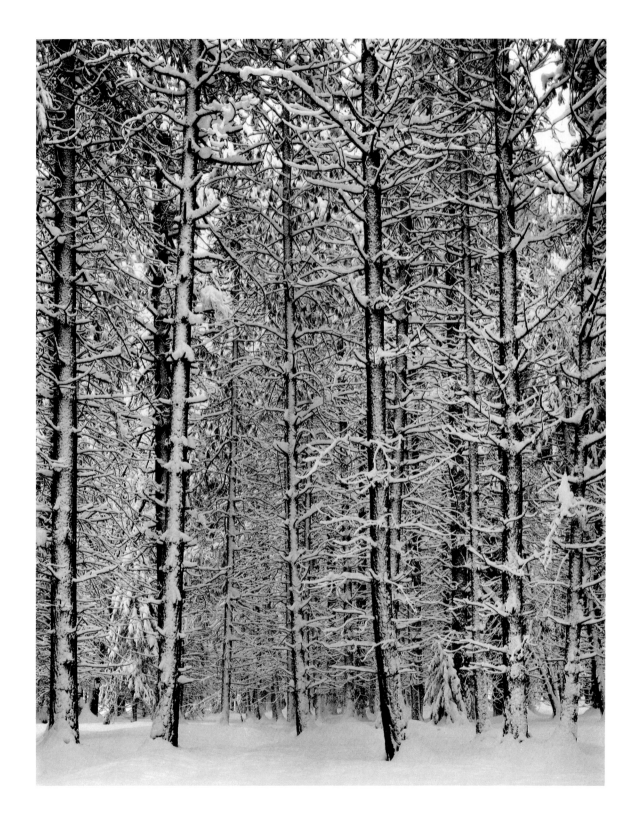

III / Plate 4

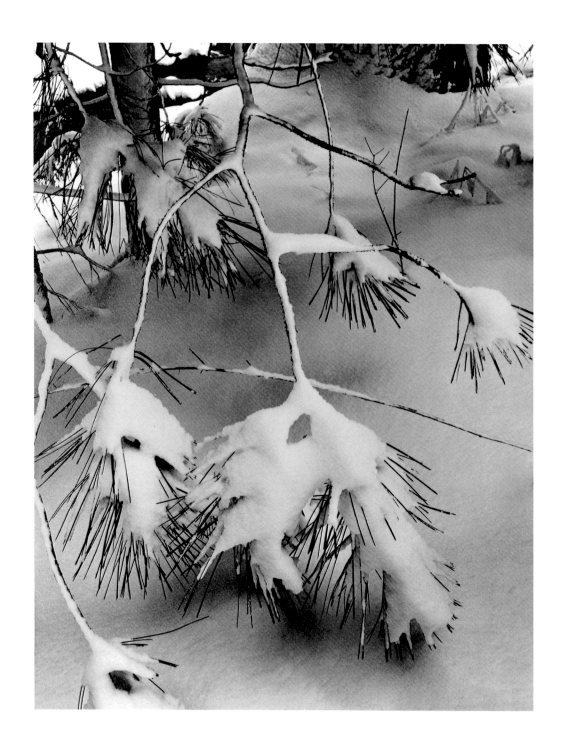

III / Plate 5

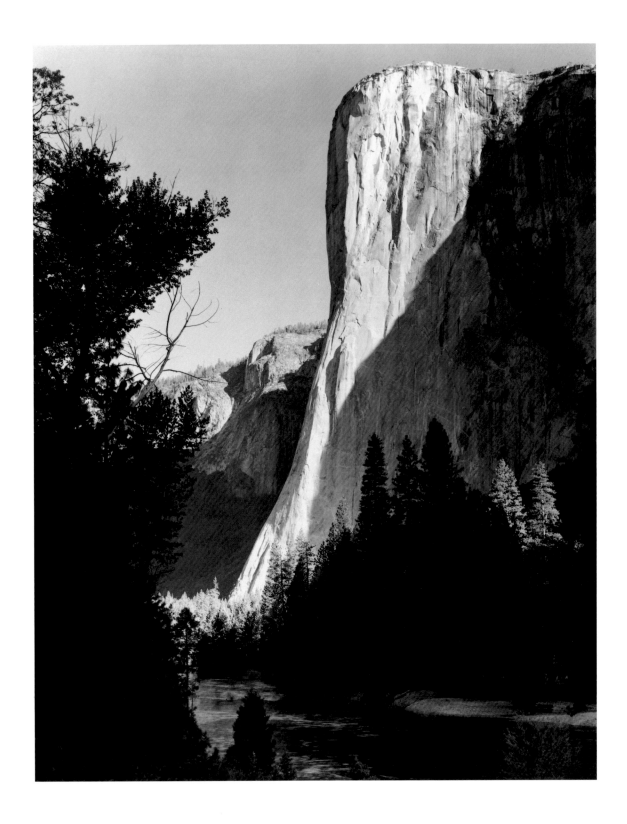

III / Plate 6

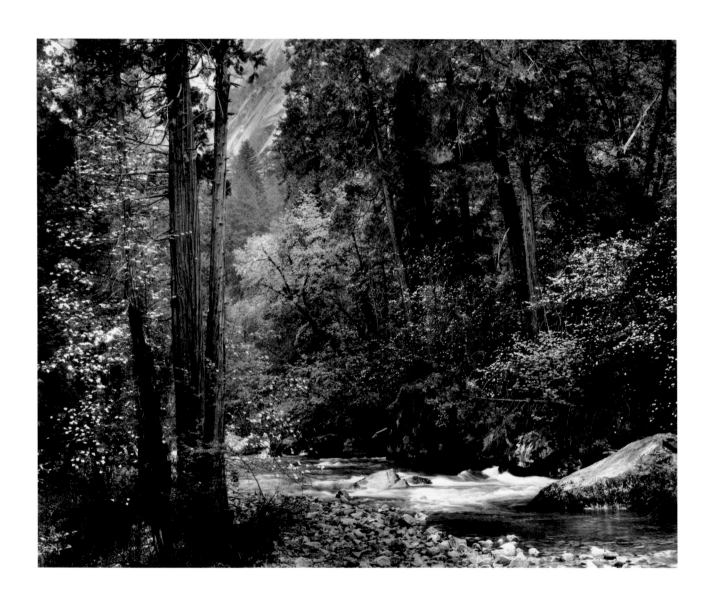

III / Plate 7

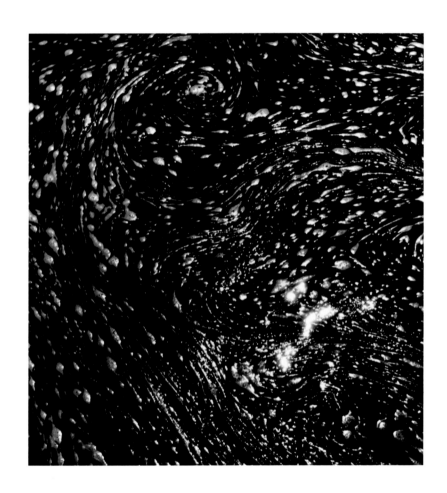

III / Plate 8

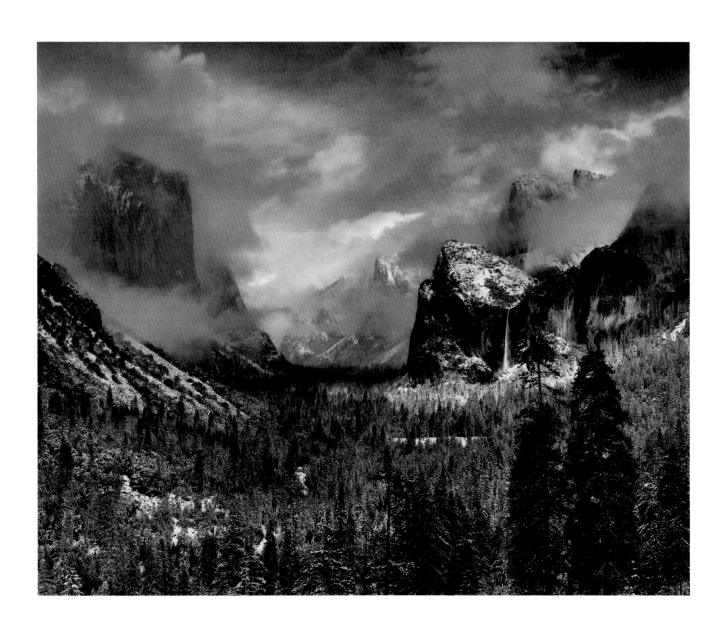

III / Plate 9

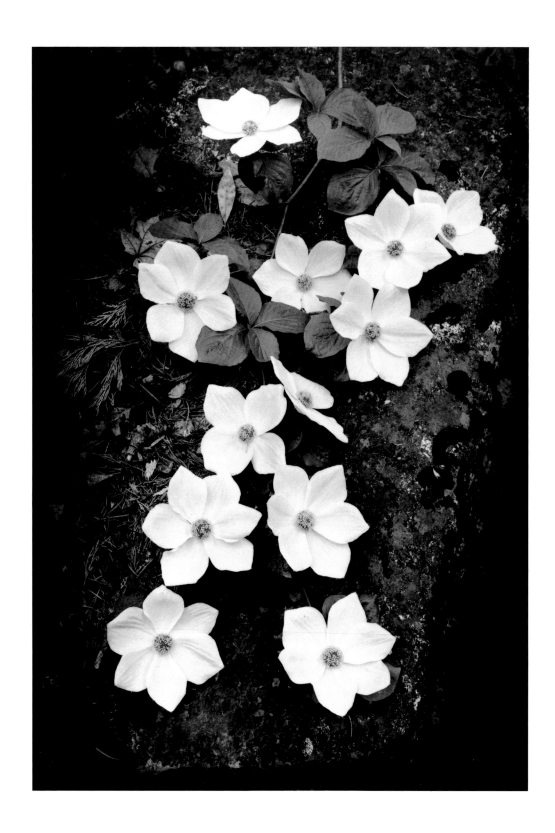

III / Plate 10

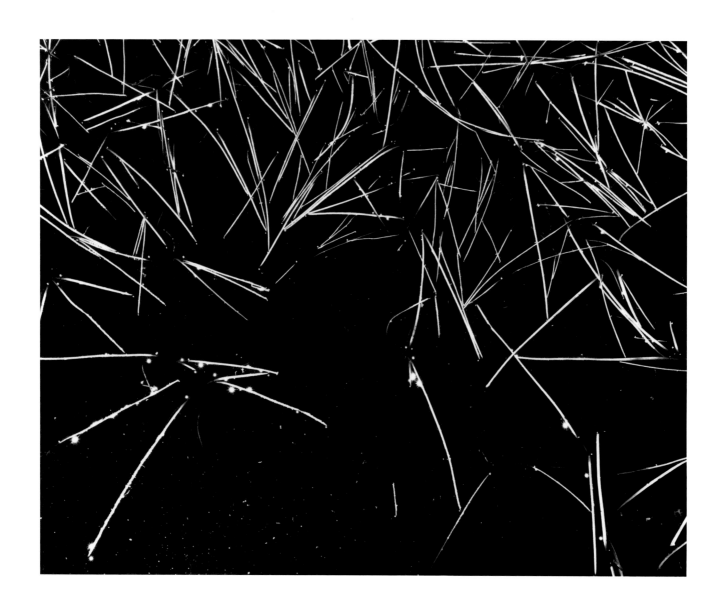

III / Plate 11

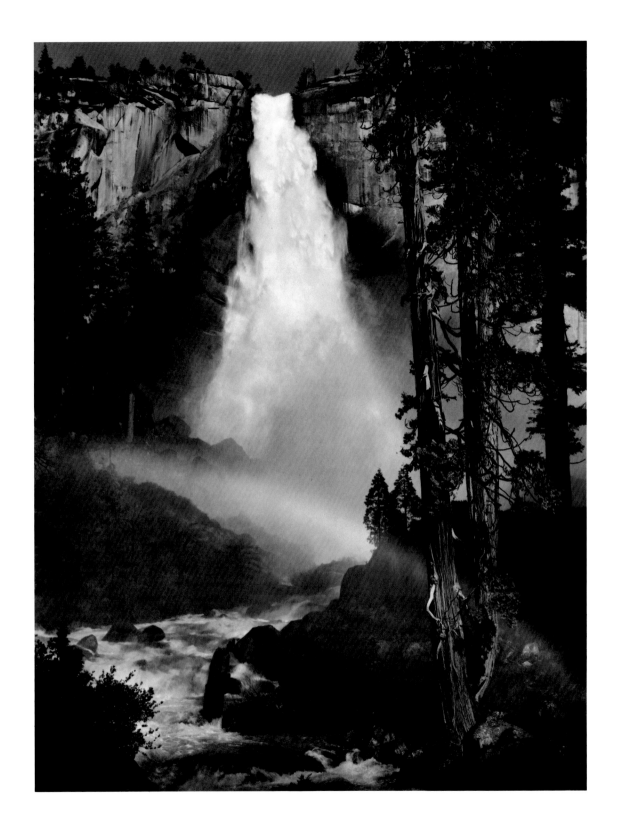

III / Plate 12

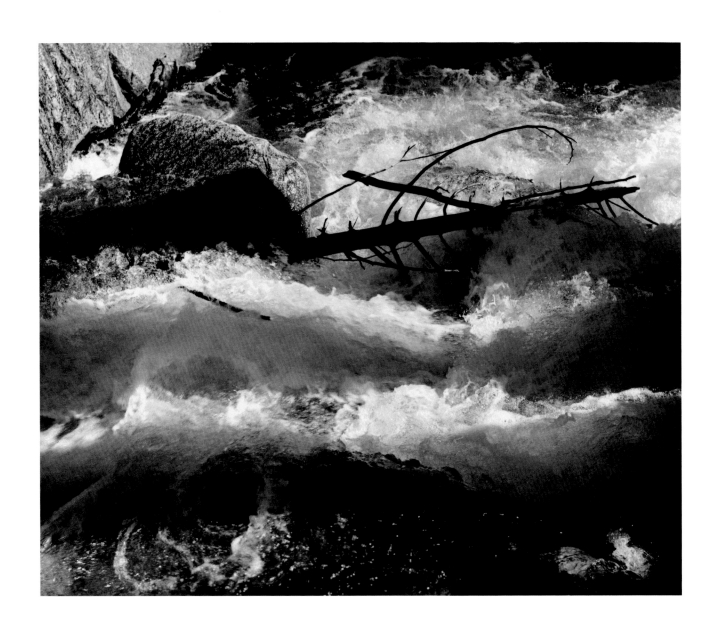

III / Plate 13

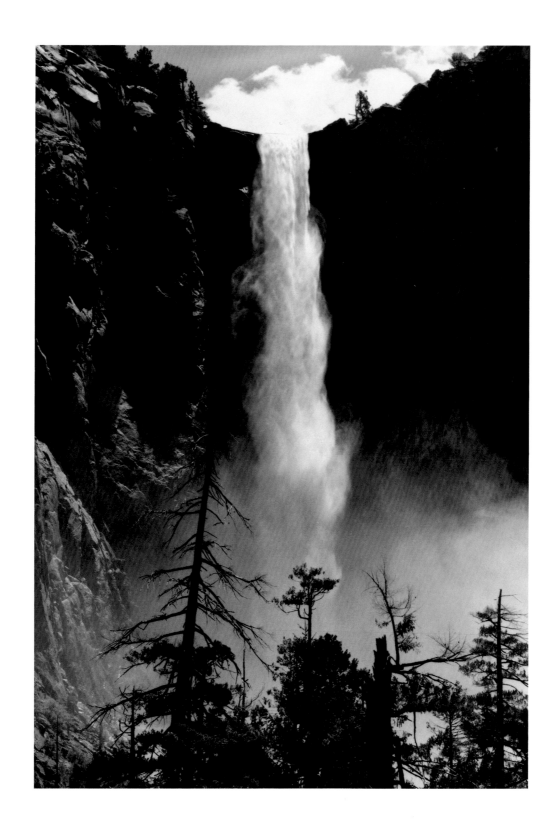

III / Plate 14

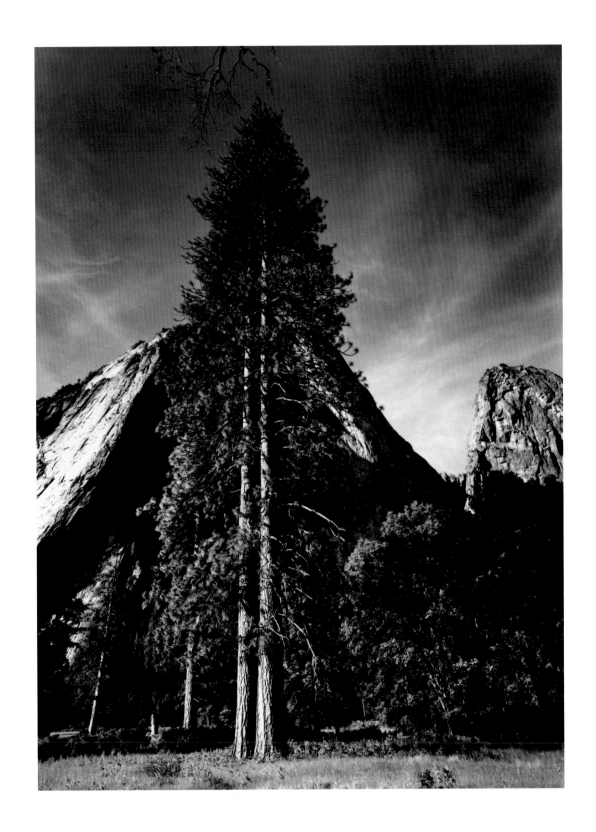

III / Plate 15

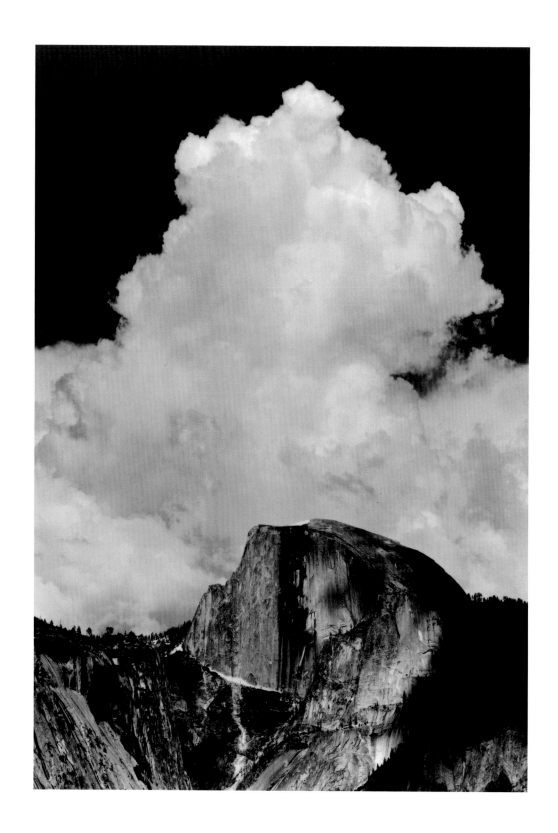

III / Plate 16

WHAT MAJESTIC WORD

In memory of Russell Varian

BY

ANSEL ADAMS

PORTFOLIO FOUR

SIERRA CLUB · SAN FRANCISCO

1963

The production of a Portfolio of creative photographs of the natural scene seemed from the start to be an appropriate expression of tribute and affection for Russell Varian. The fact that original prints were considered gave a more intense validity to the project than would obtain from reproductions in a book, no matter how fine they might be. In addition, the excerpts from his writings, and the poetry of his father, John O. Varian, accentuate the highly personal character of this presentation.

In selecting from a considerable number of appropriate images the particular and inevitable photographs for inclusion in this Portfolio I was constantly aware of a man of great intellect and mystical perceptions. To him nature was a fundamental spiritual reality. He was not a place-gatherer, or a mountain-winner, or did he in any way approach the world as prey for egotistical conquest. His Irish forebears, his poet father, his exposure to the subtle beauty of dunes and forests as a youth, and his life-long love affair with the rocks, trees, clouds, lights and storms comprising the vast Divine Performance in which we live, accumulated in him a grandeur of spirit and a magnificence of mind and heart unique in our time.

Hence, every photograph in this Portfolio is related in some direct or indirect way to the places, things and moods Russell Varian loved. In some the essences of light and space dominate; in others the substance of rock and wood, and the luminous insistence of growing things. Shapes of nature, transformed into what the artist calls forms by the controlled eye and the perceptive spirit, are presented here as the equivalents of experience. Obviously such equivalents could never be inclusive, as the experiences are practically infinite. It is my intention to present—through the medium of photography—intuitive observations of the natural world which may have meaning to the spectators, just as they might have had meaning to him. And through them I hope that some of the quality, sensitivity and heart of Russell Varian may be revealed—at least suggested to a world in need of the vast and patient benedictions of nature and the benefactions of noble men.

Carmel, California Ansel Adams
October 1, 1963

ACKNOWLEDGMENTS

What Majestic Word (Portfolio Four) by Ansel Adams is produced under the sponsorship of the Varian Foundation and published by the Sierra Club. The Foundation expresses appreciation for the advice and assistance of the following individuals: Dorothy Varian for her constructive advice and encouragement and for her monograph on Russell Varian; Dr. and Mrs. Edward Ginzton, and Mr. and Mrs. Eric Varian of Halcyon; Nancy Newhall for her valued help in selecting and editing the excerpts from the writings of Russell Varian and his father John Varian, and otherwise lending her experience and ability to the general literary and design qualities of the production; Lawton Kennedy, Printer, San Francisco, for his devoted attention to the design and printing of the texts and the individual print folders; Perry Davis, Burlingame, for the preparation of the cases; Miss Liliane De Cock for her assistance to Ansel Adams in the arduous detail in mounting, spotting and collating the prints.

Ansel Adams wishes to express his deep appreciation for permissions to use the pictures which were made for certain projects and clients: photographs I, II, III, XII and XIV were made under a Guggenheim Fellowship, photograph VII courtesy of the Skirball Ranch, photograph VIII courtesy of Sunset Petroleum Corporation, photograph X courtesy of the Sierra Club and photograph XIII courtesy, Timber Cove Properties.

This edition of PORTFOLIO FOUR is limited to 260 copies, 250 of which are for sale.

This is copy number

Fifteen original prints by Ansel Adams, Carmel

Typography and Printing by Lawton Kennedy, San Francisco

Cases by Perry Davis, Burlingame, California

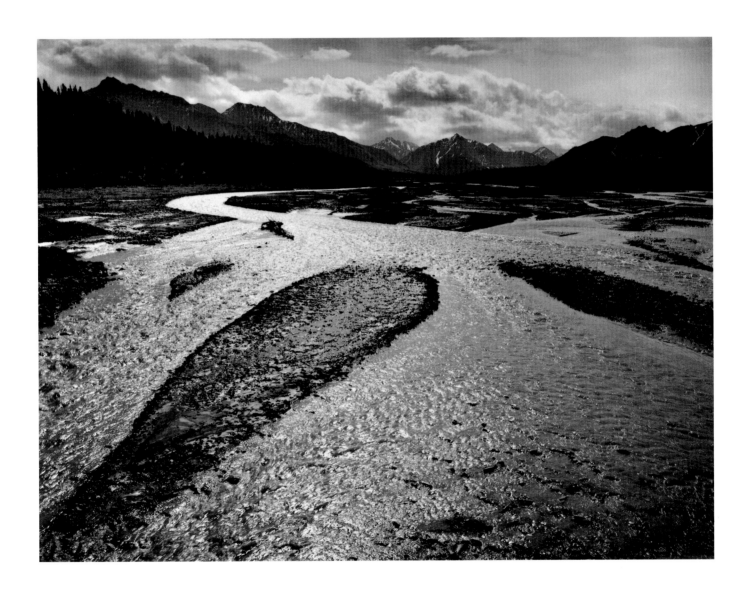

IV / Plate 1

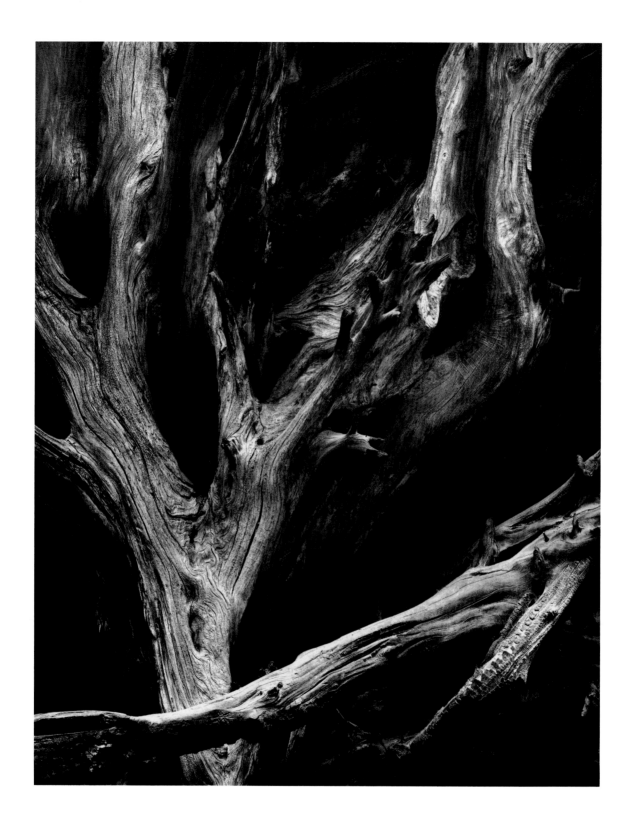

IV / Plate 2

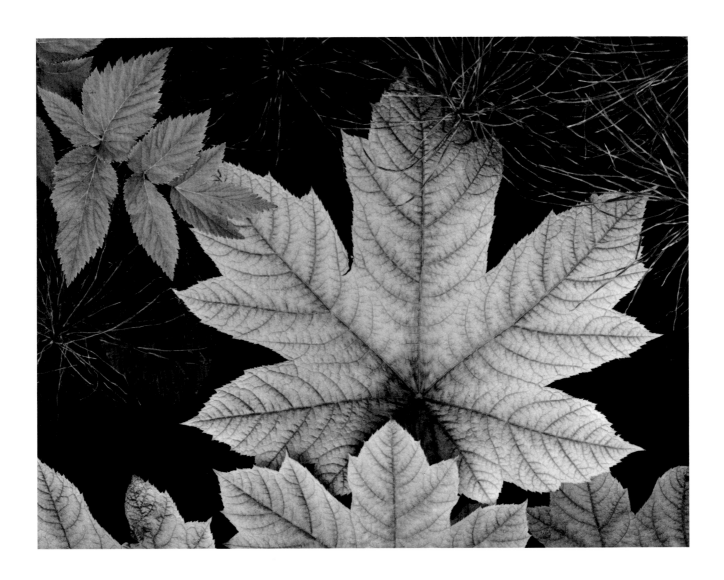

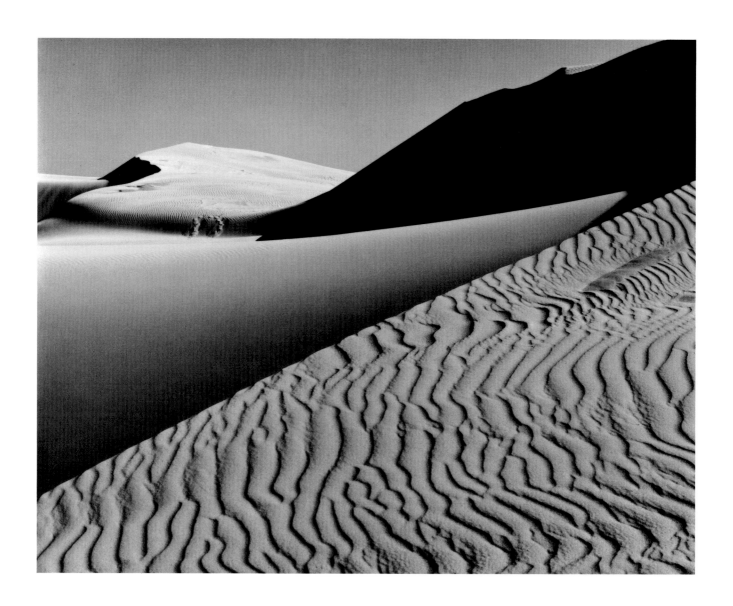

IV / Plate 4

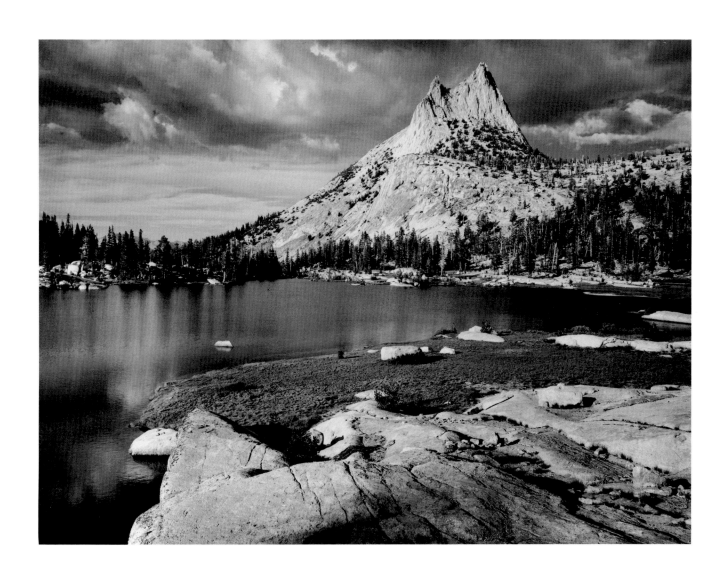

IV / Plate 5

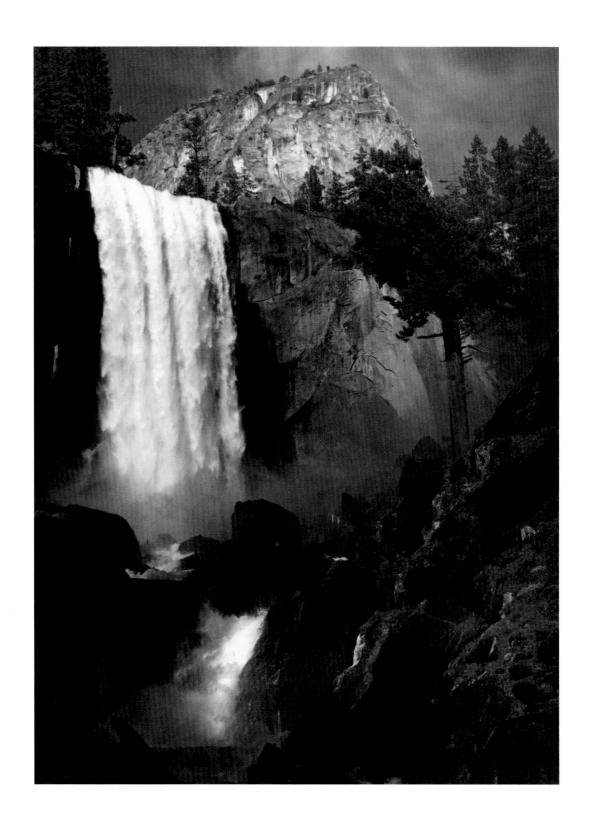

IV / Plate 6

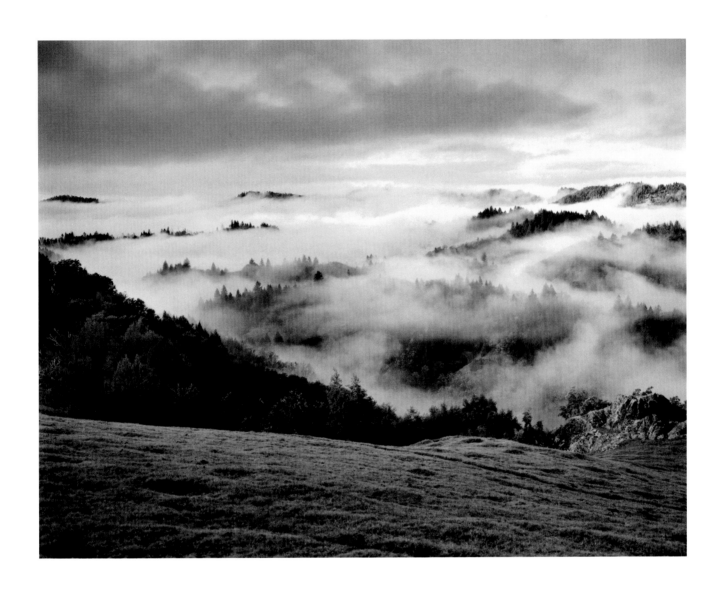

IV / Plate 7

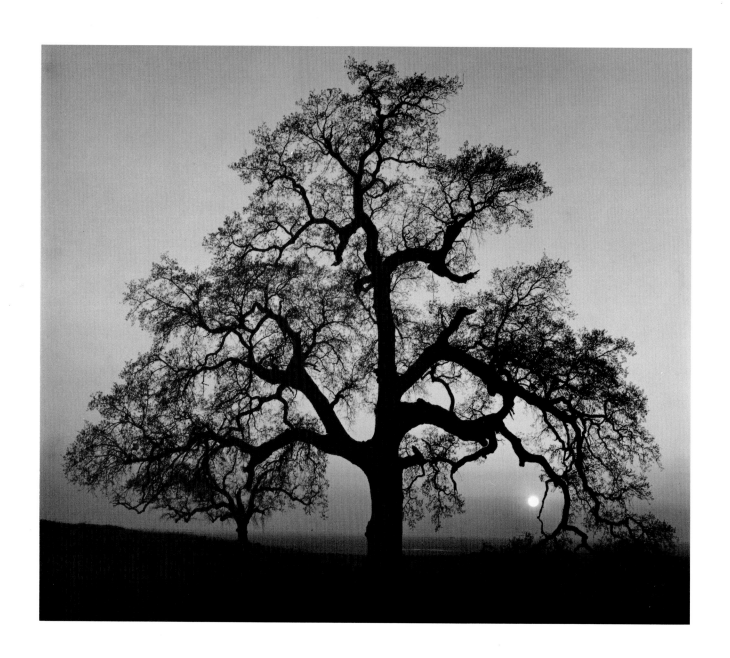

IV / Plate 8

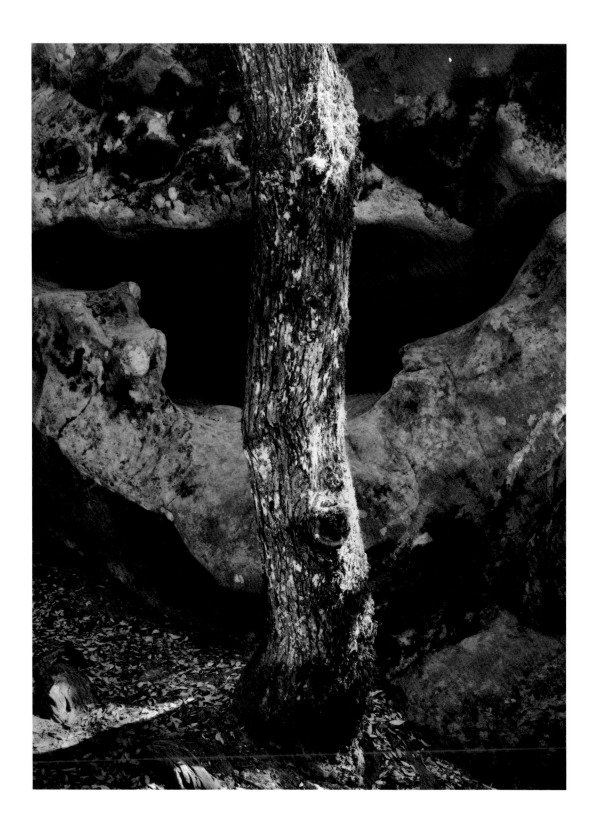

IV / Plate 9

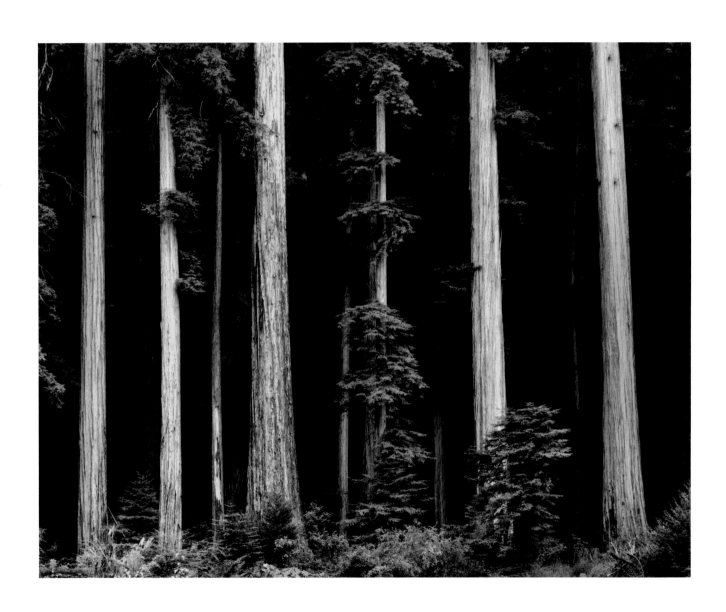

IV / Plate 10

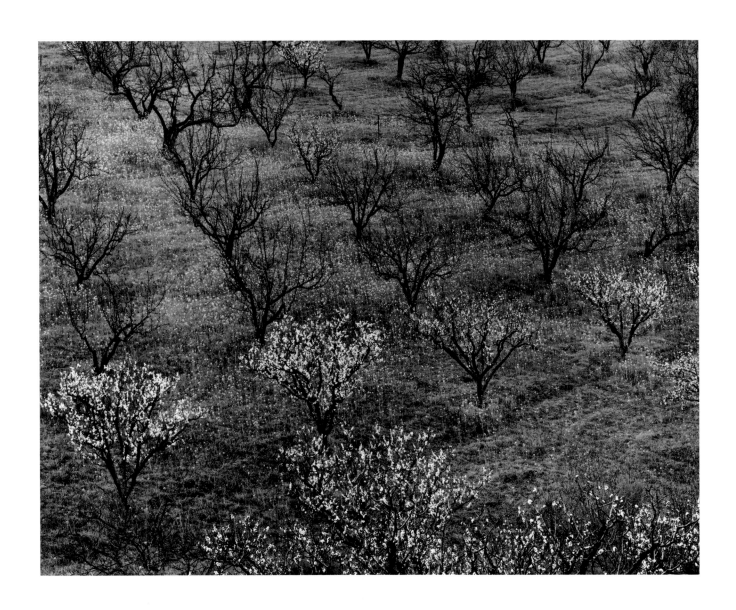

IV / Plate 11

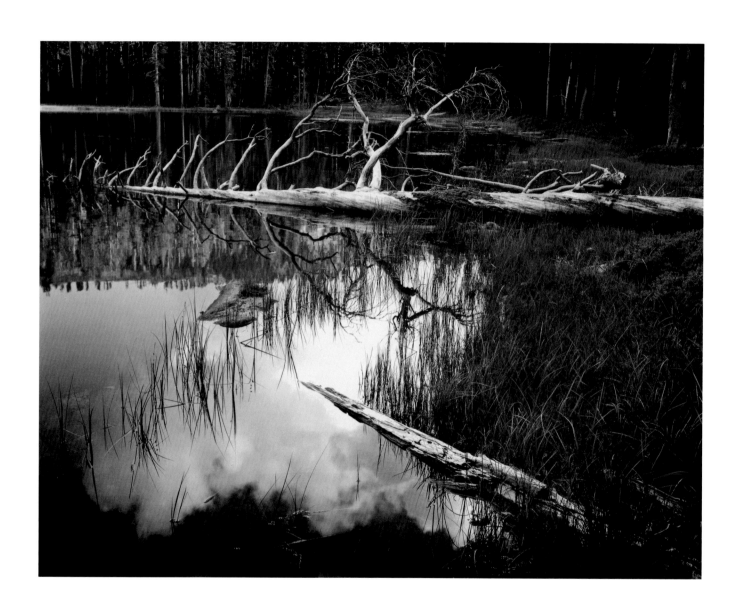

IV / Plate 12

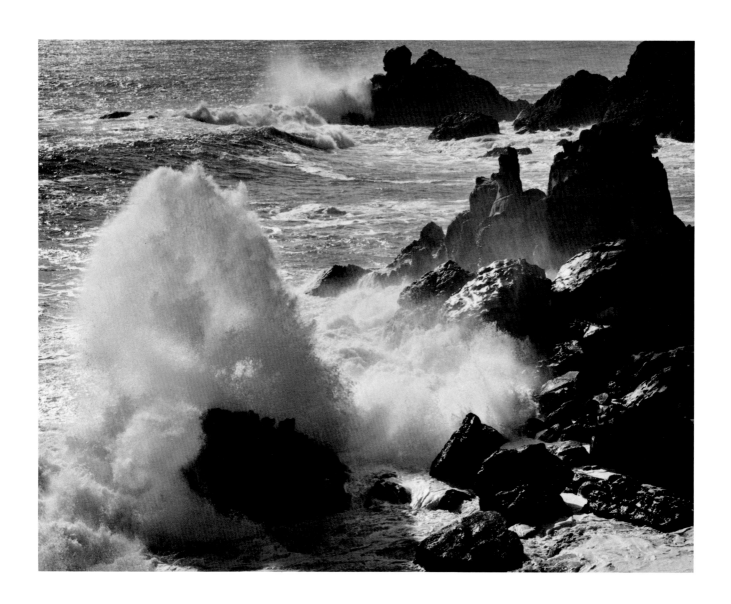

IV / Plate 13

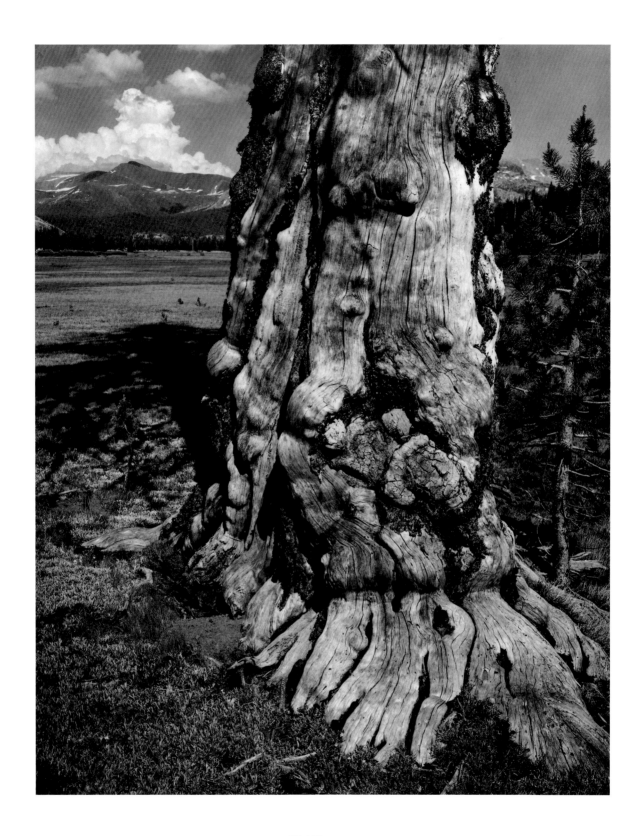

IV / Plate 14

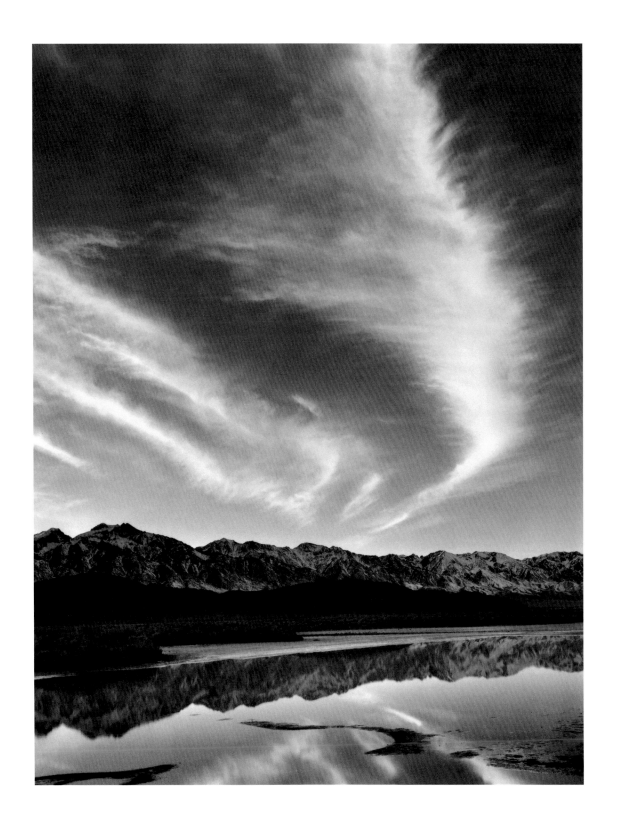

IV / Plate 15

ANSEL ADAMS PORTFOLIO V

PARASOL PRESS, LTD. NEW YORK

1970

INTRODUCTION

Man may feel he is God moving above the chaos of this world and creating his own world. Ansel Adams says there are only shapes – "configurations in chaos" – until the artist gives them form. I would turn this statement around and say this world contains or suggests more images than the whole history of art, which includes photography, has ever yet discovered. And that most of those images Man has discovered still endure, and wait somewhere for you. New images cry out to be seen and realized, even if you have turned from the literal into your own mystical or mathematical world.

So the space we must live in – cosmic, planetary, personal – is limited only by ourselves, and changes constantly as we ourselves change and grow in vision, understanding and compassion. And this portfolio of photographs proves it as completely as any collection of images I have ever seen.

It is a dazzling collection, and few have been seen before in any form, certainly not together and in prints of this size and quality. They convey a new aspect of Ansel Adams, who has never been afraid to look afresh on some of the most be-photographed places in the world, such as Yosemite and Yellowstone, as if only the wind had passed that way before.

And now he looks at some of his favorite subjects as if even he had never seen them before. The strange pinnacles of the Alabama Hills, the last fangs of a once mighty mountain range, soar up like ancient gods, glittering with the telescoped planes of their multi-eroded textures. The stark black-and-white of Lone Pine Peak, the harsh desolation of the Mudhills, where nothing grows, are followed by two images such as we might expect from Adams, the moon swept up by ethereal clouds in a never-never land, and the exquisite tapestry of forest and stream at dusk.

The Petroglyphs, with their fleeing or meditative beasts – antelopes? –
incised on shadowed rocks testify to the joy of primitive Man in the
chase of these magic animals. Then the mysterious radiance of the
Black Sun, an image mystical and disturbing, and the nostalgia and
compassion for the old woman behind the screen door, an almost ghostly
image of a total life experience. We do not need to know her name;
her face and her hands express her. She is the past looking at us.
The monumental White Stump broken by huge storms, weathered by high
mountain sunlight and deep snows, is a profound and heroic symbol.
And then we have the ominous, tortuous Pipes with their gauges,
symbols of the Industrial Jungles of our land.

What is Adams trying to say to us? He says he can't verbalize about what
only photographs can say. He says only that his portfolio seems to him
to sum up certain qualities and feelings he has not clarified before.
I think that what none of us can put into words as yet, is clear within us
once we open this portfolio. It is a profound statement by a great
photographer.

Nancy Newhall, 1970

PORTFOLIO V

Portfolio V has been produced in an edition of 110 copies, of which 100 are for sale.
There are 100 copies numbered 1 through 100 and 10 copies lettered A through J.

The publication of this portfolio was made possible through the generosity
and interest of L. M. Rosenthal & Co., New York.

The enlargements, by Ansel Adams, are made on Brovira paper (Agfa-Gevaert),
developed in Kodak Dektol and toned in selenium.
They are mounted on Strathmore 5-ply Drawing Board.

Ansel Adams states that, to the best of his knowledge and belief,
photographs 1, 2, 3, 4, 5, 7 and 10 have never been printed before,
that photographs 6, 8 and 9 have never been printed in this form and
only two or three smaller prints, proofs and a few reproductions in
exhibit catalogues have been made of the latter. Portfolio V comprises
unique prints and no further prints will be made from the negatives.

Design of the introductory pages by Adrian Wilson, San Francisco.
Composition in Centaur and Arrighi types by Mackenzie & Harris, Inc., San Francisco.
Photolithography by George Waters, San Francisco.

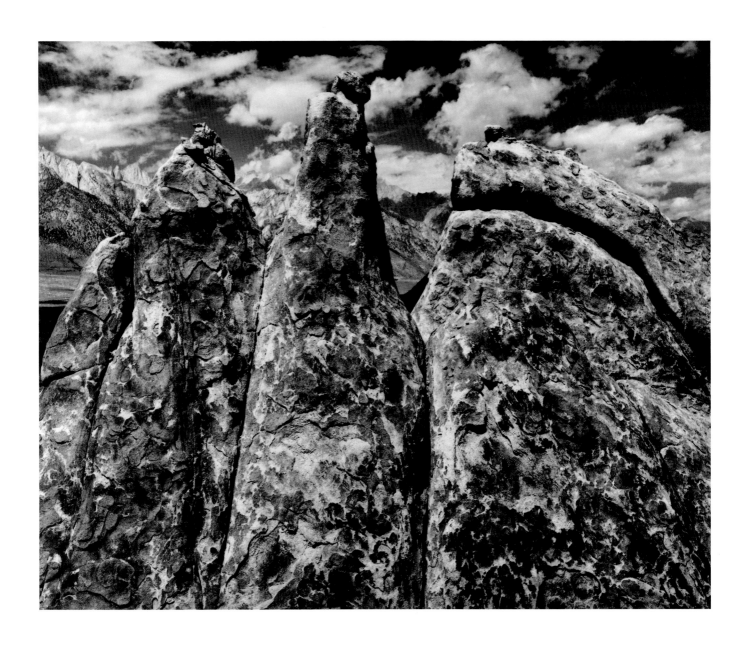

V / Plate 1

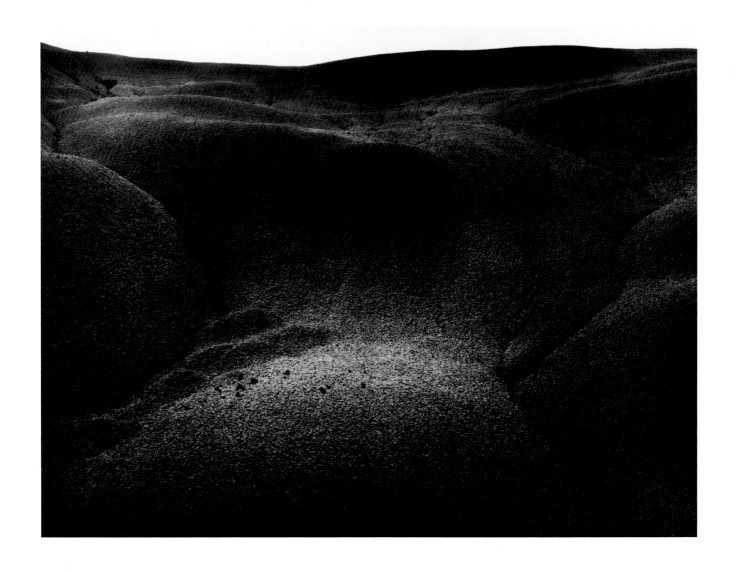

V / Plate 2

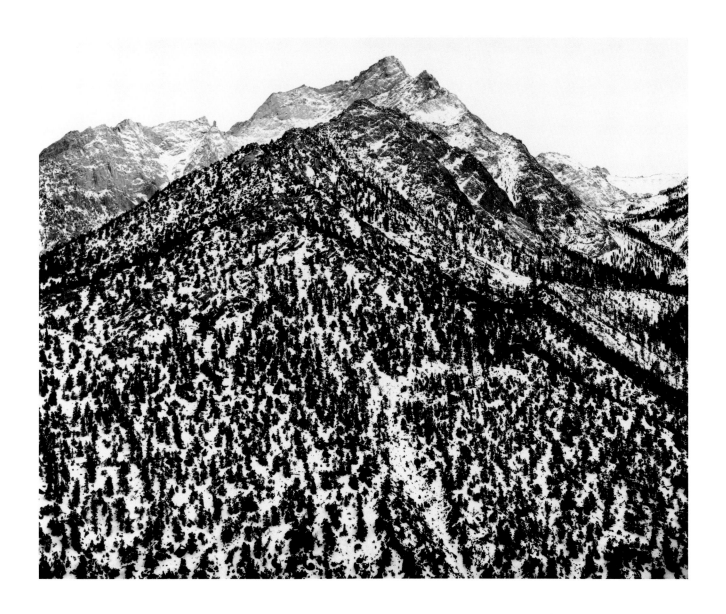

V / Plate 3

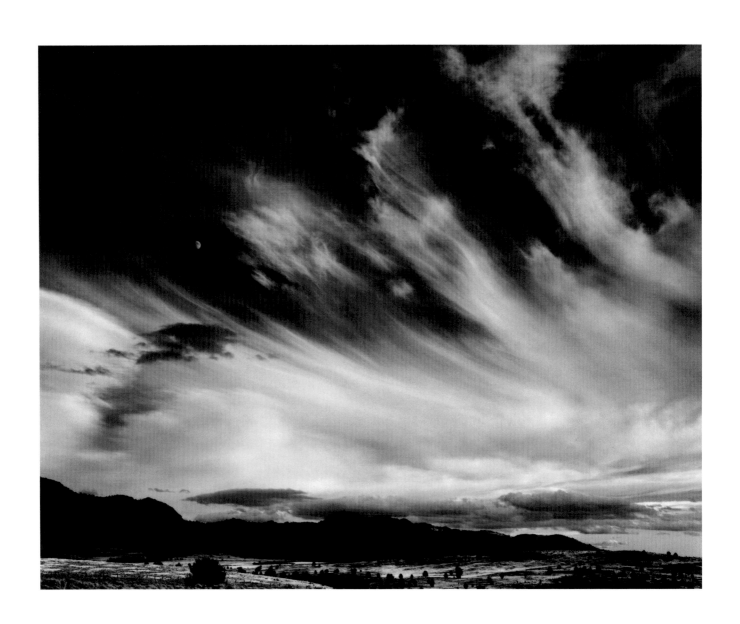

V / Plate 4

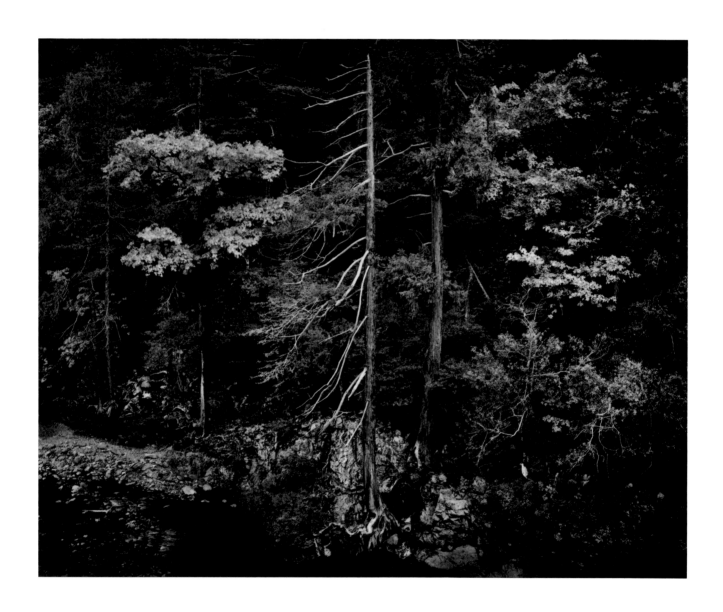

V / Plate 5

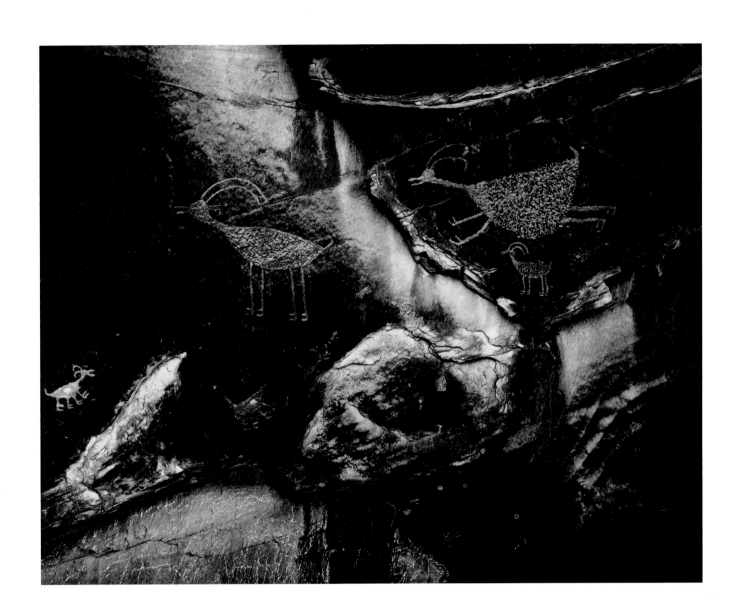

V / Plate 6

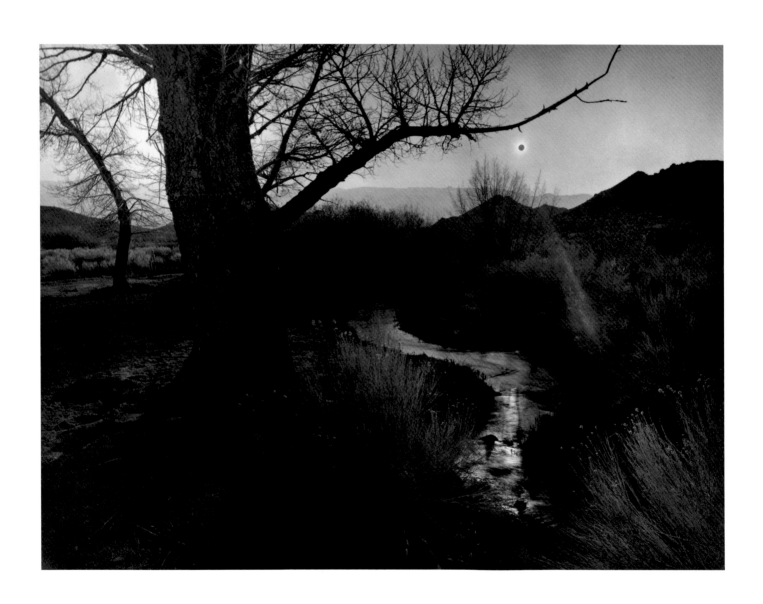

V / Plate 7

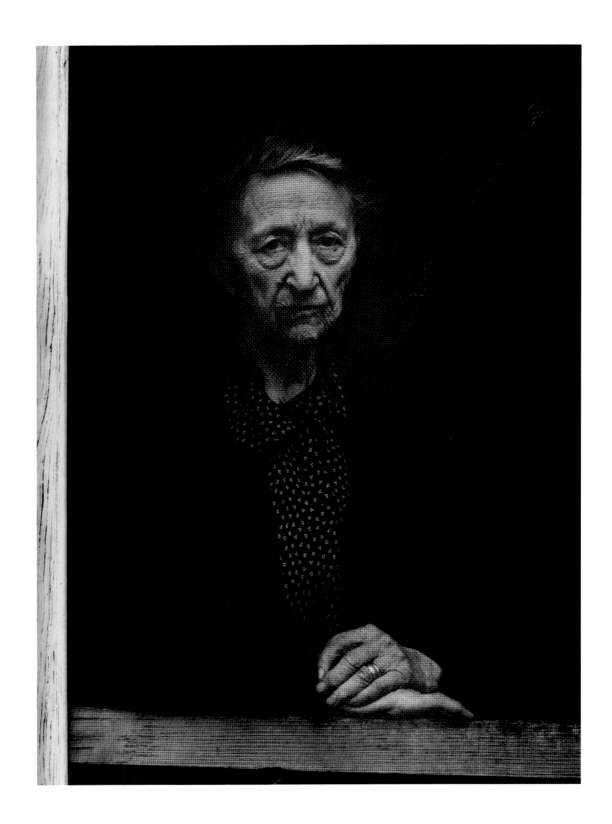

V / Plate 8

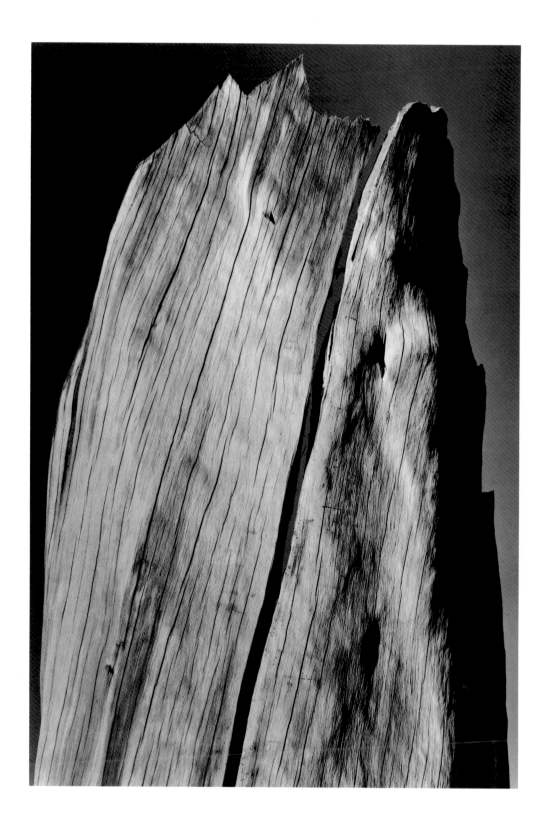

V / Plate 9

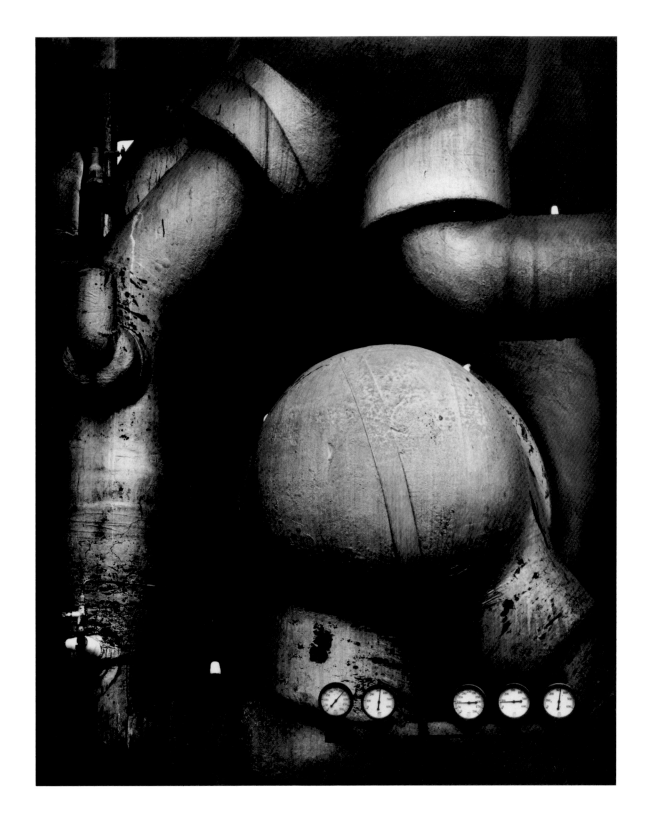

V / Plate 10

ANSEL ADAMS
PORTFOLIO VI

PARASOL PRESS, LTD.

NEW YORK

1974

PORTFOLIO VI

Dedicated with deep affection and respect to the memory of

GOTTARDO PIAZZONI

1872-1945

and

EDWARD WESTON

1886-1958

who encouraged me in so many ways to observe
the beauty of the world and challenged me to express and
interpret it through the medium of photography.

FOREWORD

Ansel Adams is having the strange experience of looking back through more than fifty years of his work. Many of us have had that curious flash of surprise and recognition when suddenly coming across some early and totally forgotten print or article, "My god, I didn't think I was that good then!" A moment later, "Why it actually has the whole mood and meaning of that time!" Or, of course, the opposite reaction, "What trash!" and into the wastebasket or the fire. That latter decision may later be regretted, but most artists seldom really regret; if they have been really good, they have been remarkably fecund. A lot of things may have "boiled the pot"—and yet some aspect of social history may cling to them; others are purely historical—people, places, houses, views, situations, and events that vanished long ago, and hence have value to libraries and societies, as indubitable documentation.

Of the creative work, what goes to the fire is usually "a sketch" for something achieved at a greater moment at a later time—the latent image finally realized. And there are the great moments some mechanical failure or pure accident prevented from being fine negatives. These are the hardest to throw out, because of their potentials, if you could find the way to solve the problems involved. Most artists have had "burnings"— cleansings, resurrections—but Adams has not, unless the negatives were really hopeless. Of course he did suffer a real fire, in 1938, in his Yosemite darkroom—somebody left the old drymounting press on—he lost many negatives, and so had to spend some time thereafter trying to replace the irreplaceable, because nothing ever happens exactly the same as

before. Still, a number of early negatives did survive, thanks mostly to Edward and Charis Weston, on duty, that night of fire, beside the bathtub, full of grime and sooty negatives, helping wash, rinse, and hang up to dry the results of fifteen years' effort with the camera. So here, some rarely seen, some unknown, and some familiar, are ten prints ranging through nearly thirty years of Adams' work. The gamut of mood and emotion is still greater: the fairy-tale, Beauty-and-the-Beast-in-the-dark-wood quality of *Graduation Dress;* the exquisite luminosity threaded with jet branches in *Fresh Snow;* the nostalgic clutch at remembered architectural splendor, flimsy as a stage set, so common in ghost towns like Columbia, in *White Post and Spandrel,* seen in the pale clear light of early morning after rain; the stiff little mining town of *Silverton,* not yet touristed, between the enormous peaks, and the sudden meditation on man's littleness and briefness compared to this earth he inhabits in *Antelope House.* Yet *Edward Weston,* little as he is, is bigger than the enormous eucalyptus on whose roots he sits. And *Gottardo Piazzoni,* climbing up to his scaffolding to begin work, was not posed, but was photographed as he was with an 8 x 10 camera in natural studio light.

Adams thinks he has been typed as "nature boy" too long and too unfairly; certainly his work with and for the Sierra Club, for Yosemite itself and his major fights for conservation have been spectacular, but they have pigeonholed him. He thinks it is time the public had a chance to see more of the immense scope of his work, and we think he is right.

As with previous portfolios, some of the photographs may be controversial,–not the expected Adams. Some may regret this fall from conventional grace; others will welcome it as a newly-revealed perspective on Adams and his reactions to man, his works, and nature. And, though all his prints, since he was in his teens, have been beautiful, the prints he can make now surpass anything he has done in the past. Perhaps they are the most beautiful prints yet made in the medium of photography.

Beaumont and Nancy Newhall

PORTFOLIO VI

1.

EDWARD WESTON

Carmel Highlands, California, 1945

2.

ANTELOPE HOUSE RUIN

Canyon de Chelly National Monument, Arizona, 1942

3.

MAROON BELLS

near Aspen, Colorado, 1951

4.

SILVERTON

Colorado, 1951

5.

GRADUATION DRESS

Yosemite Valley, California, 1948

6.

STILL LIFE

San Francisco, c. 1932

7.

WHITE POST AND
SPANDREL

Columbia, California, 1953

8.

ALDERS

Prairie Creek Beach, Northern California, c. 1949

9.

FRESH SNOW

Yosemite Valley, California, c. 1947

10.

GOTTARDO PIAZZONI
IN HIS STUDIO

San Francisco, c. 1932

PORTFOLIO VI

Portfolio VI has been produced in a limited edition of 110 copies, of which 100 are for sale.
There are 100 copies numbered 1 through 100 and 10 copies lettered A through J.

The enlargements, by Ansel Adams, are made on Brovira paper (Agfa-Gevaert),
developed in Dektol and toned in Selenium.
They are mounted on Schoellers Parole 5-ply Drawing Board, imported by Flax of San Francisco.

Ansel Adams states that, to his best knowledge and belief, photographs Nos. 2, 3, 5 and 8 have
never appeared as fine prints; that Nos. 1, 6, 7 and 9 have been rarely printed in any form;
that Nos. 4 and 10 have been printed sparingly over the years.
No prints of the quality of these in Portfolio VI have been made of any of the photographs.
Some of the photographs have been reproduced in books and journals over many years.

Portfolio VI comprises unique prints and no further prints will be made from these negatives.

Design of the introductory text pages by Adrian Wilson of San Francisco.
Composition in Centaur and Arrighi types by Mackenzie & Harris, Inc., San Francisco.
Photolithography of the text pages by George Waters, San Francisco.
Portfolio cases by Brewer & Cantelmo, New York.

I wish to express warmest appreciation to Ted Organ, Phyllis Donohue and James Taylor
for their invaluable assistance in the production of Portfolio VI.

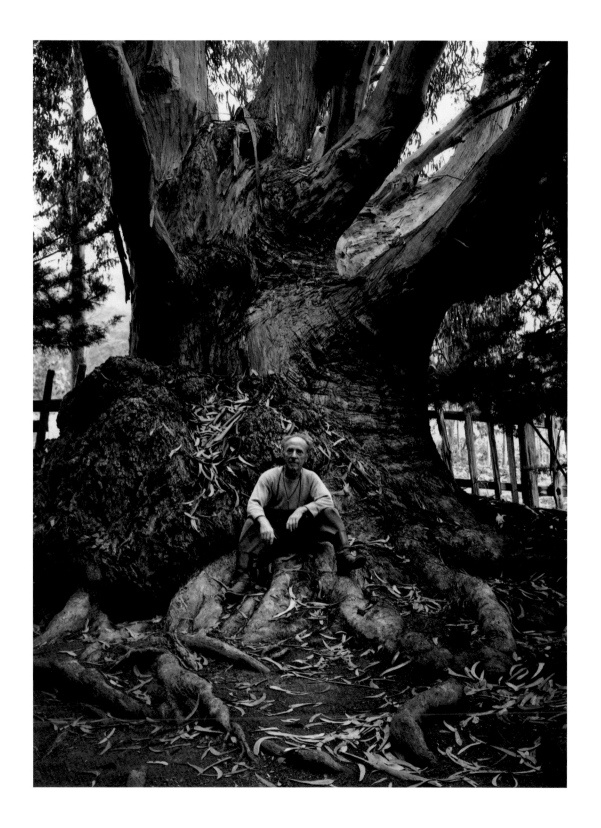

VI / Plate 1

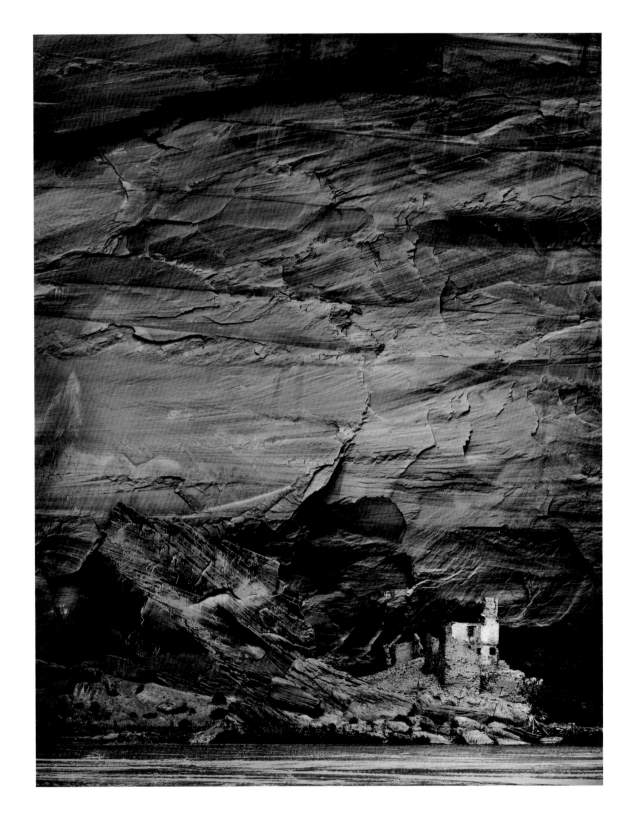

VI / Plate 2

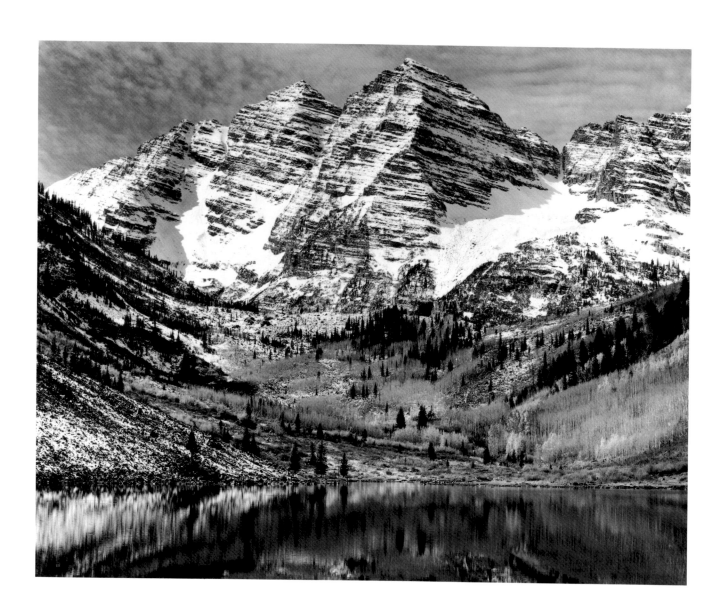

VI / Plate 3

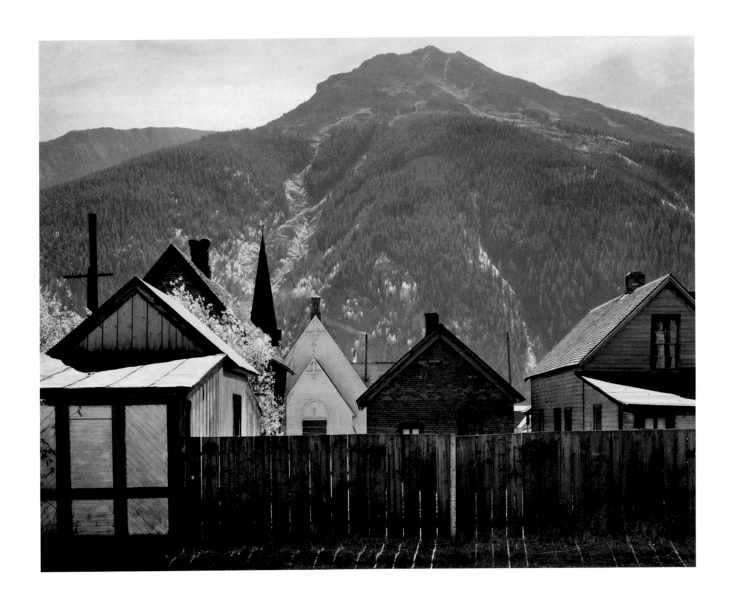

VI / Plate 4

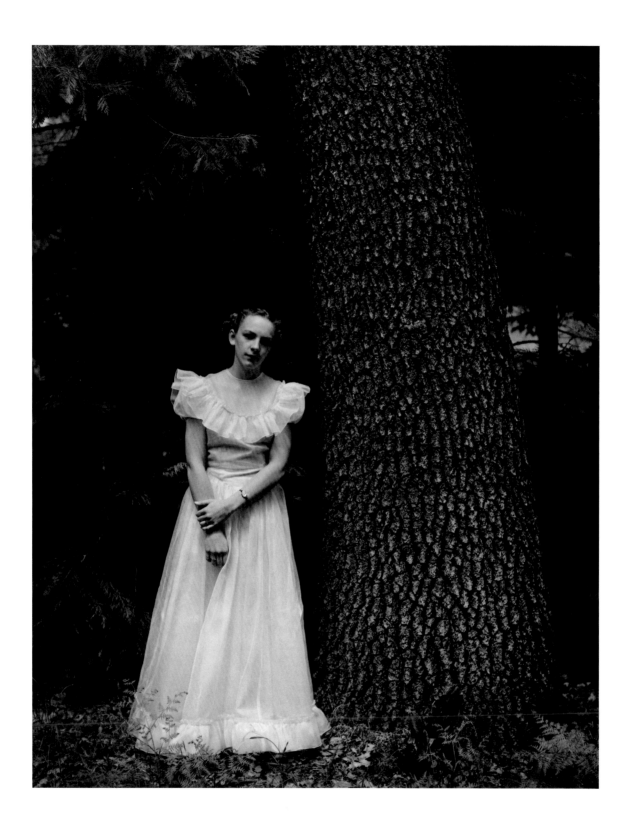

VI / Plate 5

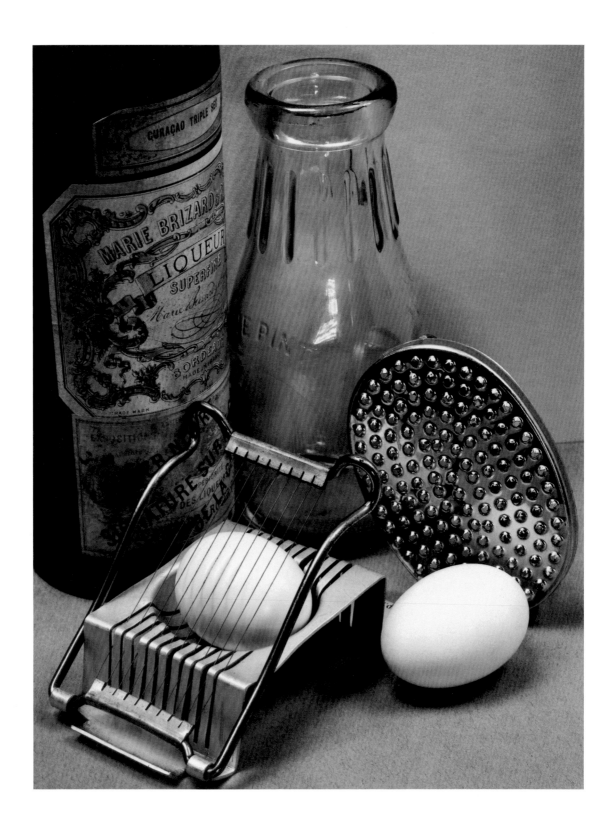

VI / Plate 6

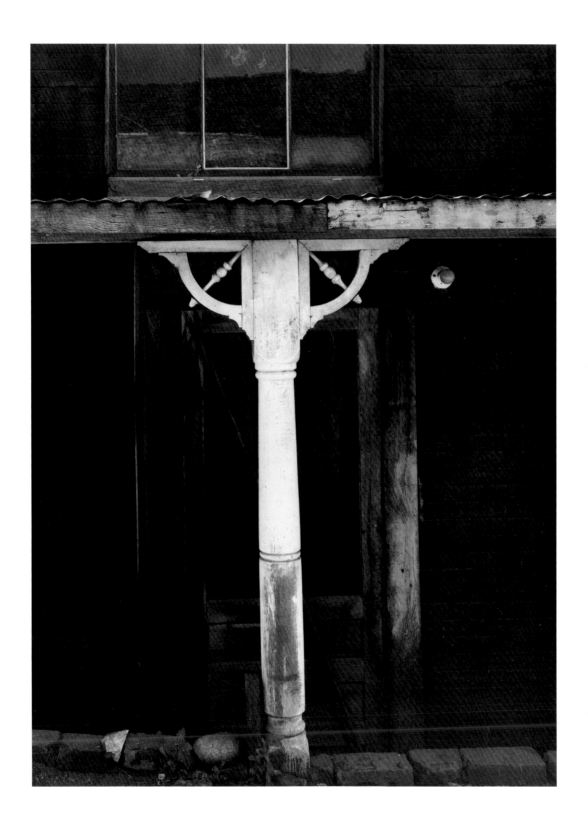

VI / Plate 7

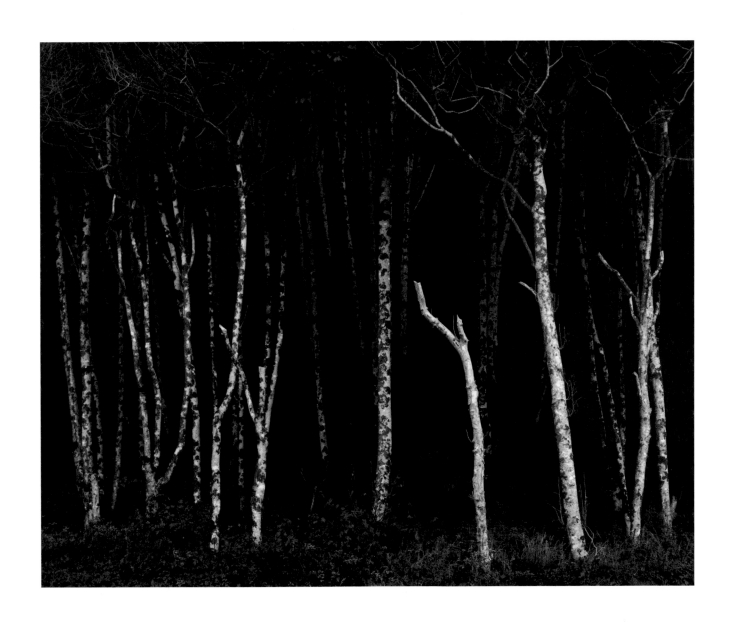

VI / Plate 8

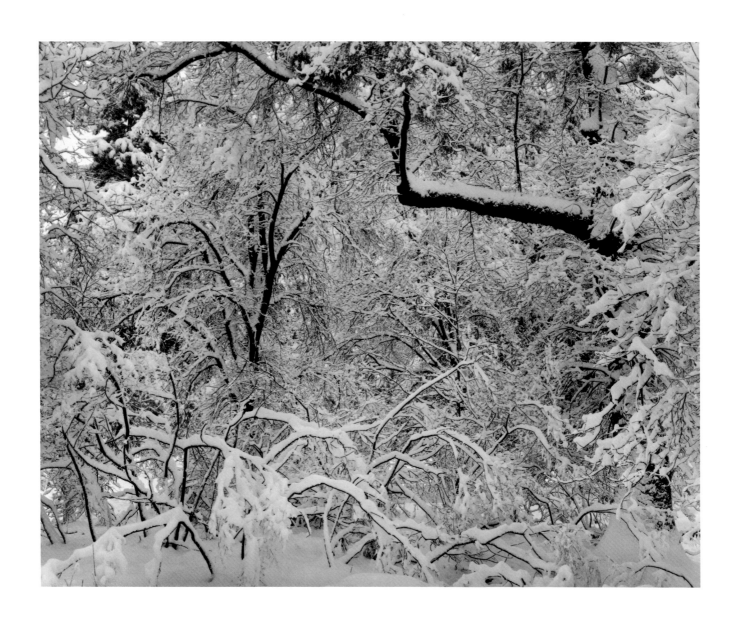

VI / Plate 9

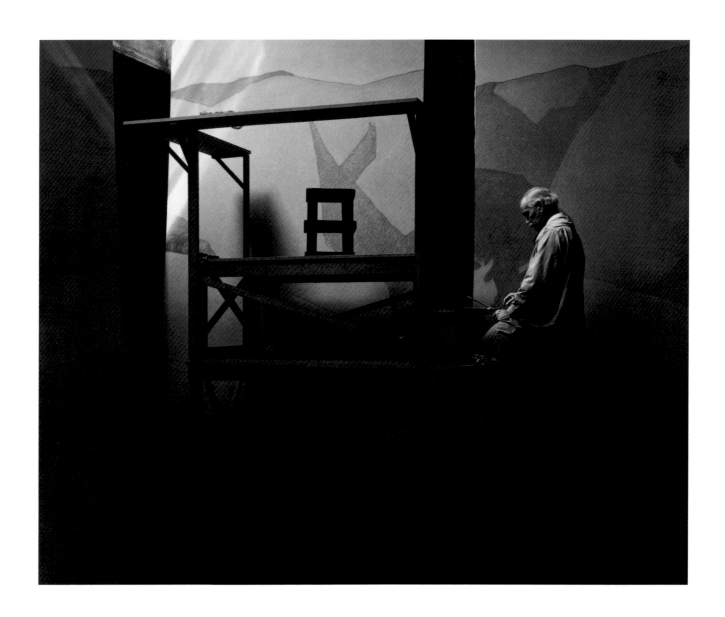

VI / Plate 10

ANSEL ADAMS
PORTFOLIO VII

PARASOL PRESS, LTD.

NEW YORK

1976

PORTFOLIO VII

Dedicated to

David Hunter McAlpin

FOREWORD

This portfolio of original prints represents a partial vista of my life in photography. I think of them as equivalents of expression—to borrow Alfred Stieglitz' explicit term. I hope that my work will encourage self-expression in others and stimulate the search for beauty and creative excitement in the great world around us.

To repeat a statement I have frequently made: the negative is comparable to the composer's score and the print to its performance. Each performance differs in subtle ways. When I look now at the negative of "Boards and Thistles," made over forty years ago, the wonder and excitement of the creative event are sharply revived. This image represents the threshold of my experience in the clear, straight vision of photography; the essence of the Group f/64 approach. I hope that the original creative impact is not only retained but also expanded by the perceptions and techniques acquired over the intervening years.

Dedicating this portfolio to David Hunter McAlpin gives me the opportunity to pay homage to a great friend and a true benefactor of photography. Over at least forty years our friendship has revolved around excursions, visits, exchange of ideas, projects and the warm response stimulated by mutual interests in creative work. His timely support made possible the formation of the Department of Photography at the Museum of Modern Art in New York and the Chair of the History of Photography at Princeton University. Generous donations from his fine collection of photographs have benefited many

organizations. I am proud that among his early acquisitions were examples of work from my first exhibition, at An American Place in New York City in 1936. I find it difficult to imagine how photography might have developed or what directions my own work would have taken had it not been for the vitality of effort and understanding he contributed to the medium.

I am both pleased and honored to have worked through more than half a century in the world of photography, and to have observed its ever-expanding potential as a medium of expression and communication. The original Polaroid Land print in this portfolio represents for me a voyage into the future. New aspects of seeing, new means of communication, new qualities of image and new levels of subjective and intellectual comprehension lie ahead. While I have always worked with fairly conventional means and techniques, I anticipate new departures which, if I cannot examine them in my lifetime, will assure the power of future vision and accomplishment.

Ansel Adams
Carmel
May, 1976

PORTFOLIO VII

PORTFOLIO VII

Portfolio VII has been produced in a limited edition of 115 copies, of which 100 are for sale.
There are 100 copies numbered 1 through 100 and 15 copies lettered A through O.
No further prints will be made from the negatives.

The enlargements were made by Ansel Adams on Agfa-Gevaert Brovira and
Kodabromide papers, developed in Dektol and toned in Selenium.
They are mounted on Lenox Museum 4-ply Mounting Board
made by the Rising Paper Company, distributed by Flax's of San Francisco.

The original Polaroid Land photograph was made on Type 52/PolaPan Land Film directly
in the camera. The title is on the verso of the mount.

A separate sheet herewith discusses elements of care and presentation of the prints in the portfolio.

Design of the introductory text pages by Adrian Wilson of San Francisco.
Composition in Centaur and Arrighi types by Mackenzie-Harris Corp., San Francisco.
Photolithography of the text pages by George Waters, San Francisco.
Portfolio cases by Brewer & Cantelmo, New York.

I wish to express thanks and appreciation to Alan Ross, Norman Locks, Phyllis Donohue,
Jim Taylor, Andrea and Bill Turnage and Bob Feldman
for their invaluable encouragement and assistance in the production of Portfolio VII.

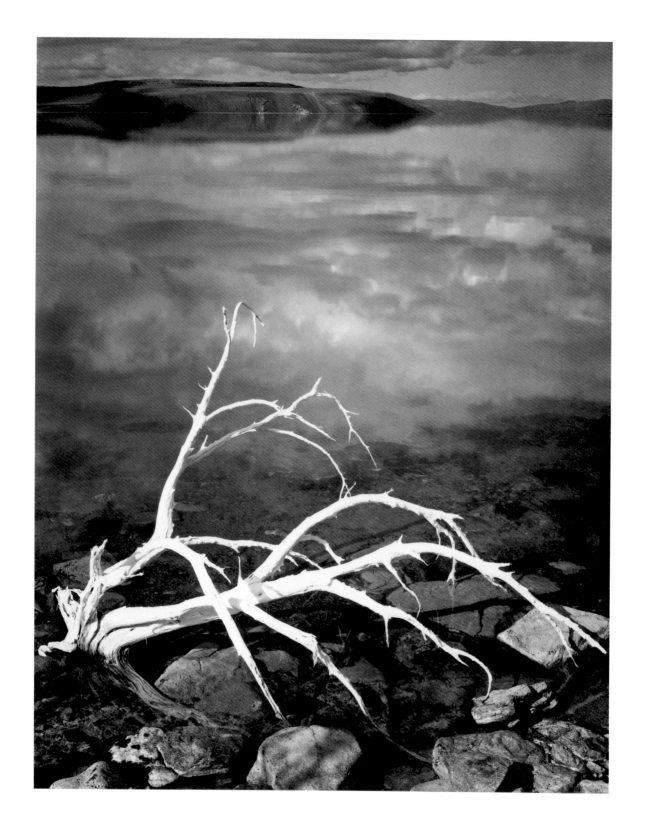

VII / Plate 1

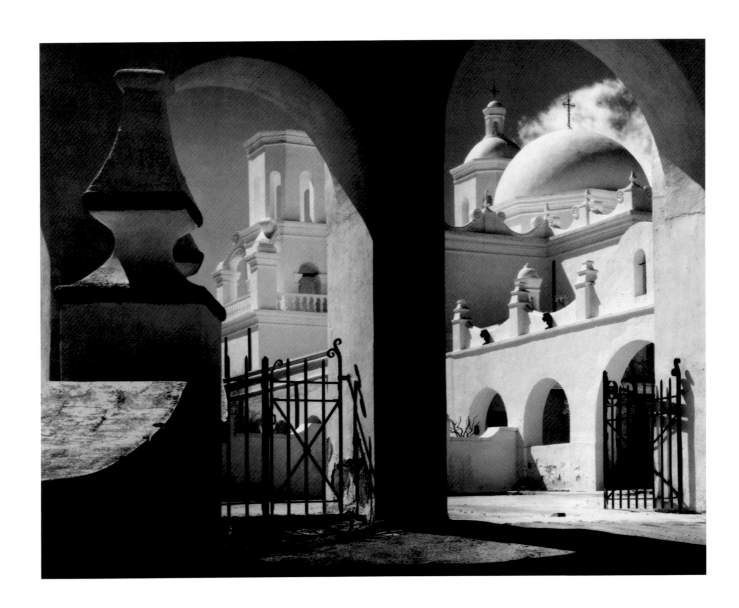

VII / Plate 2

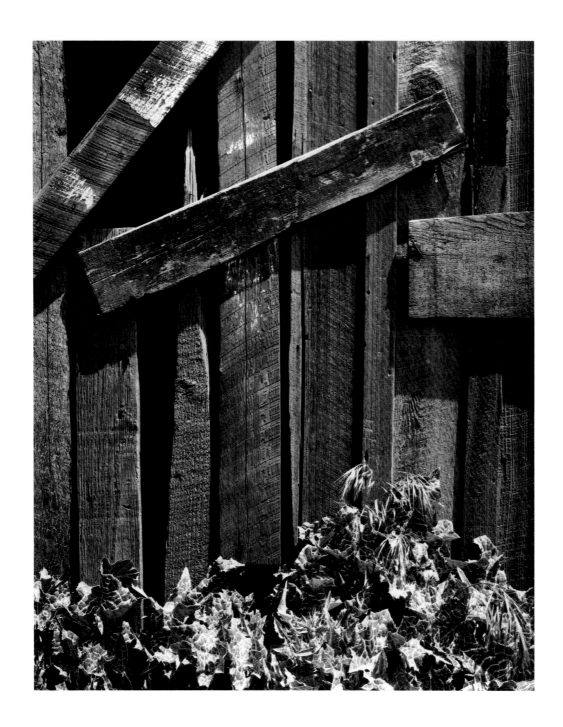

VII / Plate 3

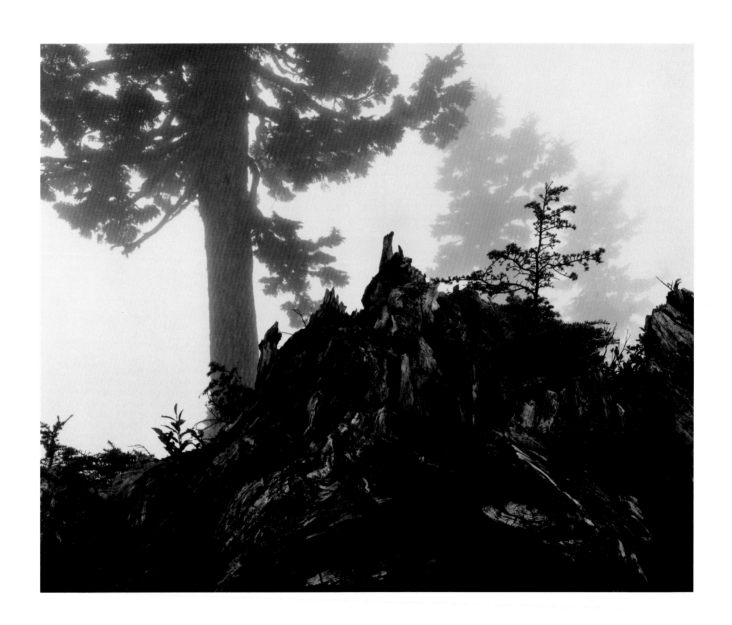

VII / Plate 4

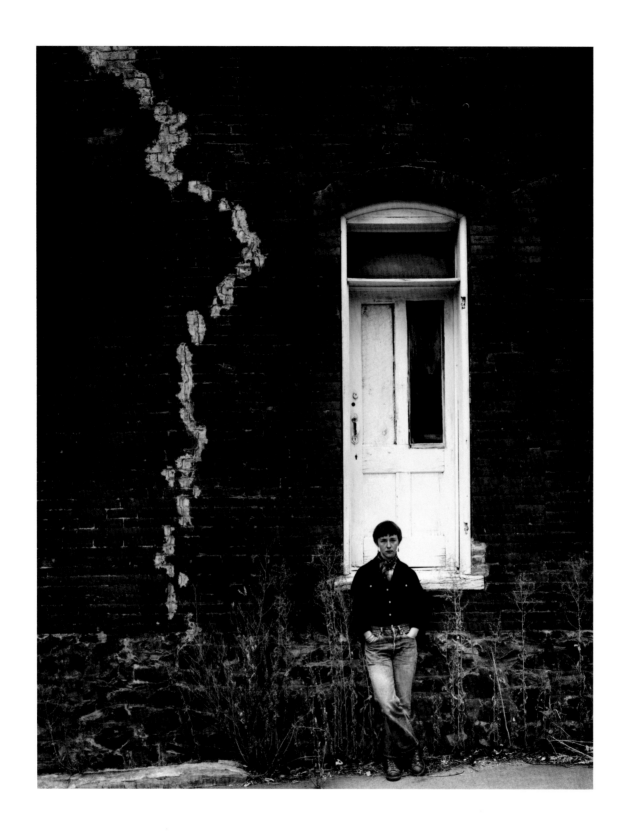

VII / Plate 5

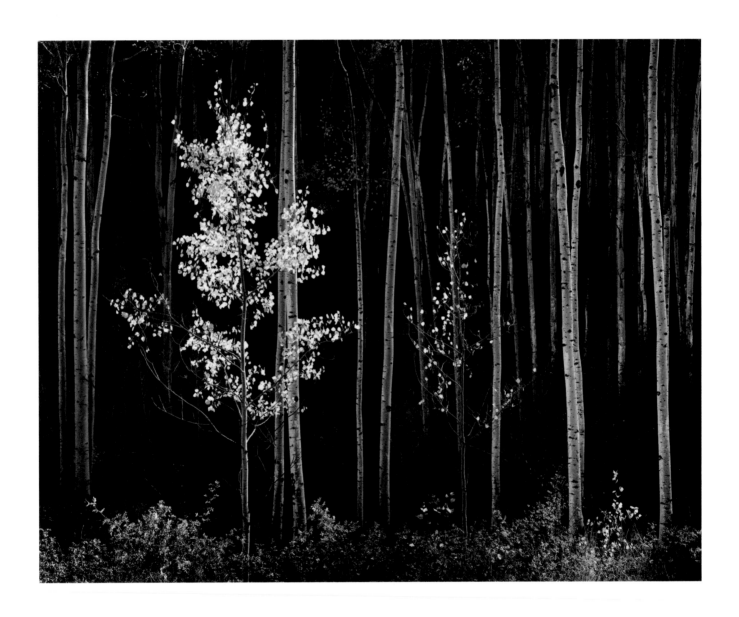

VII / Plate 6

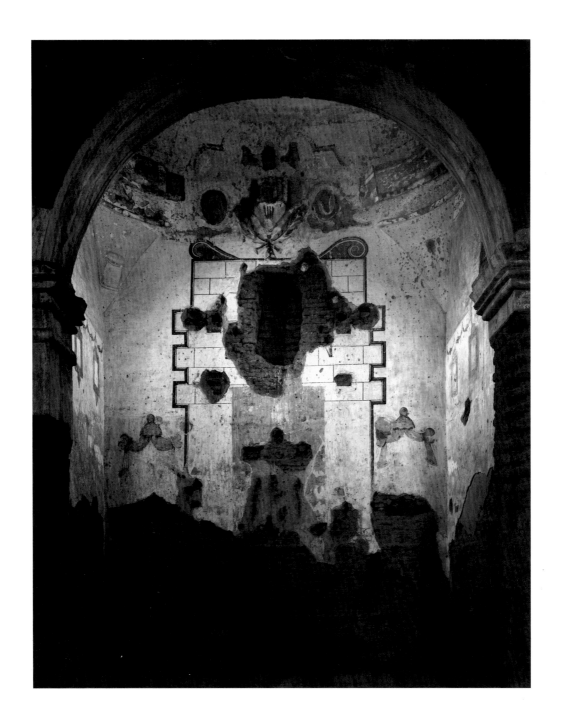

VII / Plate 7

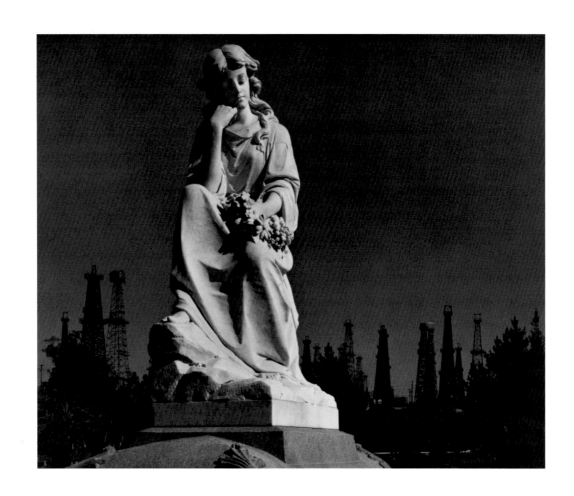

VII / Plate 8

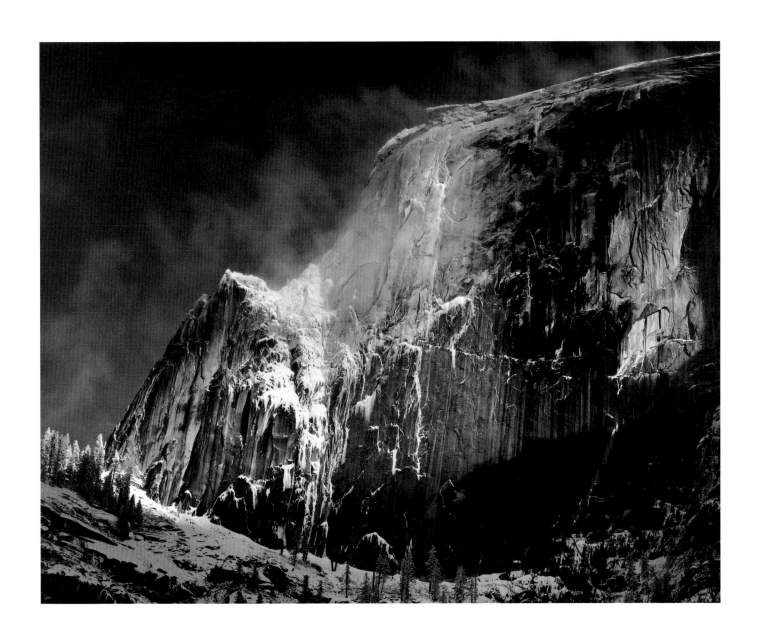

VII / Plate 9

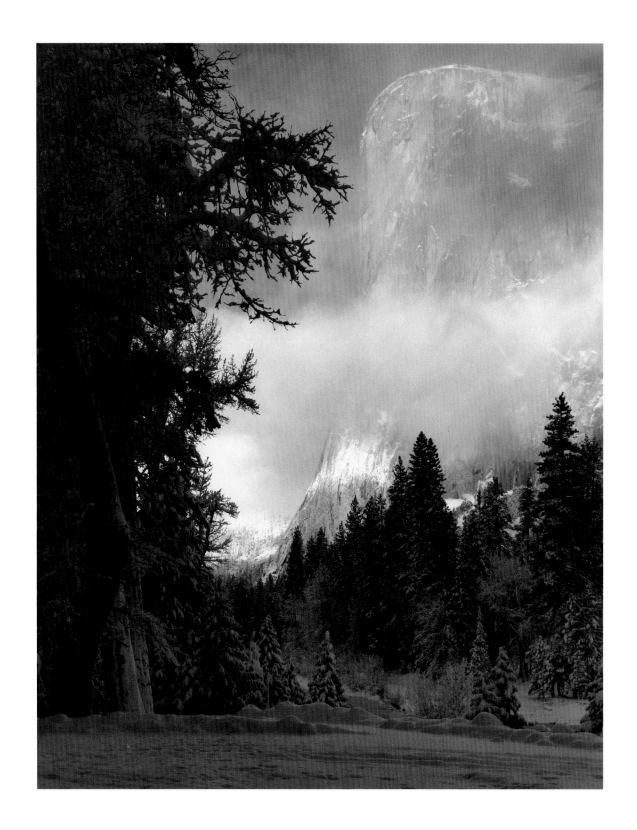

VII / Plate 10

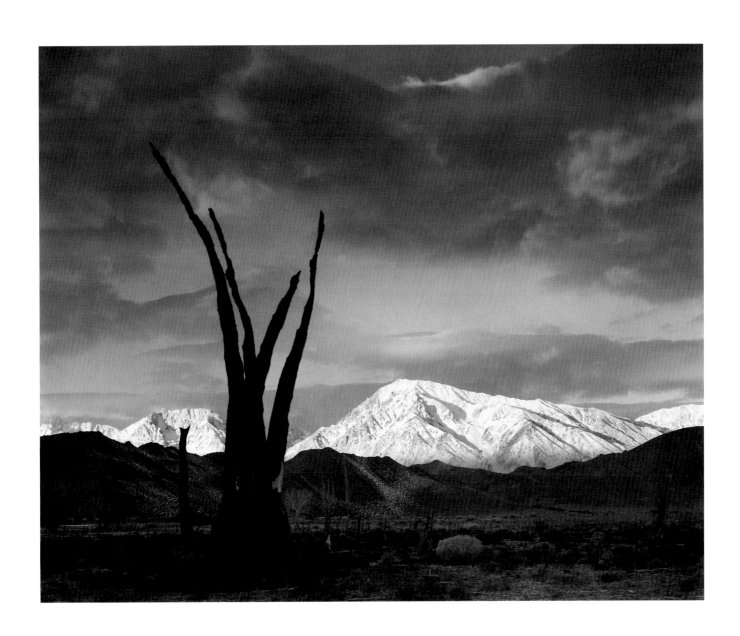

VII / Plate 11

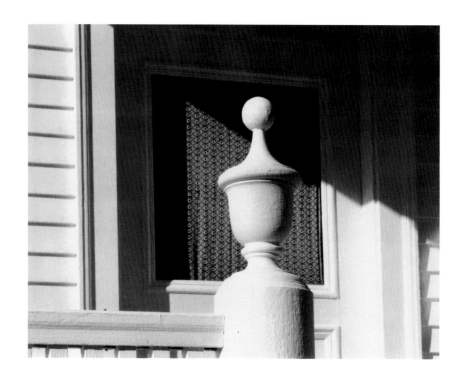

VII / Plate 12

LIST OF THE PRINTS

PORTFOLIO I, *1948*

1. Mount McKinley, Alaska, 1948
2. Saguaro cactus, sunrise, Arizona, 1946
3. Rapids below Vernal Fall, Yosemite Valley, California, 1948
4. Mormon Temple, Manti, Utah, 1948
5. Vine and rock, Island of Hawaii, T.H., 1948
6. Refugio Beach, California, 1946
7. The White Church, Hornitos, California, 1946
8. Roots, Foster Gardens, Honolulu, T.H., 1948
9. Oak tree, snow storm, Yosemite Valley, California, 1948
10. Trailside, near Juneau, Alaska, 1948
11. Alfred Stieglitz, An American Place, New York, 1938
12. Clouds above Golden Canyon, Death Valley, California, 1946

PORTFOLIO II, *1950*
The National Parks & Monuments

1. Noon clouds, Glacier National Park, Montana, 1942
2. Forest, early morning, Mount Rainier National Park, Washington, 1949
3. Dunes, hazy sun, White Sands National Monument, New Mexico, 1941
4. White House Ruin, morning, Canyon de Chelly National Monument, Arizona, 1949
5. From Hurricane Hill, Olympic National Park, Washington, 1948
6. Moth and stump, Interglacial Forest, Glacier Bay National Monument, Alaska, 1949
7. Sentinel Rock, winter dusk, Yosemite National Park, California, 1944
8. Afternoon sun, Crater Lake National Park, Oregon, 1943
9. In Joshua Tree National Monument, California, 1942
10. Rain, Beartrack Cove, Glacier Bay National Monument, Alaska, 1949
11. Dead tree, Sunset Crater National Monument, Arizona, 1947
12. Zabriskie Point, Death Valley National Monument, California, 1942
13. Old Faithful Geyser, late evening, Yellowstone National Park, Wyoming, 1942
14. The Atlantic, Schoodic Point, Acadia National Park, Maine, 1949
15. Dawn, autumn forest, Great Smoky Mountains National Park, Tennessee, 1948

PORTFOLIO III, *1960*
Yosemite Valley

1. Monolith, the face of Half Dome, 1927
2. Merced River, cliffs of Cathedral Rocks, autumn, 1939
3. Lower Yosemite Fall, ca. 1946
4. Trees and snow, 1933
5. Branches in snow, ca. 1932
6. El Capitan, sunrise, 1956
7. Tenaya Creek, spring rain, ca. 1948
8. Water and foam, ca. 1955
9. Winter storm, 1944
10. Dogwood blossoms, 1938
11. Grass and pool, ca. 1935
12. Nevada Fall, rainbow, ca. 1947
13. Rushing water, Merced River, ca. 1955
14. Bridalveil Fall, ca. 1952
15. Trees and cliffs, 1954
16. Half Dome, thunder cloud, ca. 1956

PORTFOLIO IV, *1963*
What Majestic Word

1. Teklanika River, Mount McKinley National Park, Alaska, 1947
2. Sequoia roots, Mariposa Grove, Yosemite National Park, California, ca. 1950
3. Leaf, Glacier Bay National Monument, Alaska, 1948
4. Dunes, Oceano, California, 1963
5. Cathedral Peak and Lake, Yosemite National Park, California, ca. 1960
6. Vernal Fall, Yosemite Valley, California, ca. 1948
7. Clearing storm, Sonoma County Hills, California, 1951
8. Oak tree, Sunset City, Sierra Foothills, California, 1962
9. Castle Rock, Summit Road above Saratoga, California, 1963
10. Northern California coast redwoods, ca. 1960
11. Orchard, early spring, near Stanford University, California, ca. 1940
12. Siesta Lake, Yosemite National Park, California, ca. 1958
13. Storm surf, Timber Cove, California, ca. 1960
14. Tuolumne Meadows, Yosemite National Park, California, 1941
15. Sierra Nevada, winter evening, from the Owens Valley, California, 1962

PORTFOLIO V, *1970*

1. Pinnacles, Alabama Hills, Owens Valley, California, 1945
2. Mudhills, Arizona, 1947
3. Lone Pine Peak, Sierra Nevada, California, ca. 1960
4. Moon and clouds, Northern California, 1959
5. Forest and stream, Northern California, 1959
6. Petroglyphs, Monument Valley, Utah, 1958
7. The Black Sun, Tungsten Hills, Owens Valley, California, 1939
8. Woman behind screen door, Independence, California, ca. 1944
9. White stump, Sierra Nevada, California, ca. 1936

10. Pipes and gauges, West Virginia, 1939

PORTFOLIO VI, *1974*

1. Edward Weston, Carmel Highlands, California, 1945
2. Antelope House Ruin, Canyon de Chelly National Monument, Arizona, 1942
3. Maroon bells, near Aspen, Colorado, 1951
4. Silverton, Colorado, 1951
5. Graduation dress, Yosemite Valley, California, 1948
6. Still life, San Francisco, California, ca. 1932
7. White post and spandrel, Columbia, California, 1953
8. Alders, Prairie Creek Beach, Northern California, ca. 1949
9. Fresh snow, Yosemite Valley, California, ca. 1947
10. Gottardo Piazzoni in his studio, San Francisco, California, ca. 1932

PORTFOLIO VII, *1976*

1. White branches, Mono Lake, California, 1950
2. Arches, north court, Mission San Xavier del Bac, Tucson, Arizona, 1968
3. Boards and thistles, San Francisco, California, 1932
4. Tree, stump and mist, Northern Cascades, Washington, 1958
5. Gerry Sharpe, Ouray, Colorado, 1958
6. Aspens, Northern New Mexico, 1958
7. Interior of Tumacacori Mission, Arizona, ca. 1952
8. Cemetery statute and oil derricks, Long Beach, California, 1939
9. Half Dome, blowing snow, Yosemite National Park, California, ca. 1955
10. El Capitan, sunrise, winter, Yosemite National Park, California, ca. 1968
11. Sunrise, Mount Tom, Sierra Nevada, California, ca. 1948
12. Original Polaroid PolaPan Type 52 Land Photograph (Newel Post, Canterbury, New Hampshire, 1975)